# BETTER MADE in Michigan

## THE SALTY STORY OF DETROIT'S BEST CHIP

### KAREN DYBIS

AMERICAN PALATE

Published by American Palate
A Division of The History Press
Charleston, SC  29403
www.historypress.net

Copyright © 2015 by Karen Dybis
All rights reserved

First published 2015

Manufactured in the United States

ISBN 978.1.62619.985.9

Library of Congress Control Number: 2015942276

*To my family. To the people who make potato chips.
And to Detroiters near and far who love them.*

# Contents

# Acknowledgements

*Pray for peace and spiritual food, for wisdom and guidance, for all these are good,*
*but don't forget the potatoes.*

*—John Tyler Pettee*

Some conversations stick in your head long after you've had them. One such moment happened when I interviewed Nick Nicolay, president of Kar's Nuts in Madison Heights, Michigan. Mr. Nicolay told me about his grandfather and his potato chip company called New Era. He mentioned that there once were dozens of chippers in Detroit, and I was astounded. My curiosity and subsequent research about these companies led to this project. I offer many thanks to Nick for sharing his family's story and snack food legacy.

Special thanks go to Better Made Snack Foods, as well as to the families of Cross Moceri and Pete Cipriano. I appreciate your willingness to come on board when I suggested this book. Having your personal photos and recollections took this seed of a story about the industry's early years into the modern era. Thank you to Better Made's executive team, especially Mark Winkelman, Mark Costello and Mike Esseltine, for your help and trust throughout this project. Thanks to company publicist Franklin Dohanyos for telling me about National Potato Chip Day and securing my first Better Made interview. Thank you to the company's longtime employees, especially George Orris, Phil Amigoni and Russ Leone, for putting up with endless questions about what it was like to work for Detroit's first chippers. Your

# ACKNOWLEDGEMENTS

priceless photos helped me imagine just how heavy those bags of potatoes must have been.

Thank you to Betty Dancey Godard for your incredible memories about your father, Russell V. Dancey, and his partner, Ernest Nicolay, at New Era Potato Chip Company. Your stories about Best Maid and New Era were among my favorites—they provided the best historical gossip of my journalistic career.

Thank you to Dirk Burhans for your insights on the potato chip industry. Your book, *Crunch!*, never left my side during this process, and I appreciate how much work you put into its creation.

Thank you to the Detroit Drunken Historical Society and its members for their insights, which resulted in many new finds for this book. Thanks to Rachel Lutz, whose clever mind created the term "chipreneurs," which is scattered throughout this work. I also have endless gratitude to friends—including Jessica Killenberg-Muzik, Blayne Brocker, Susie Thibault, LeeAnn Jurczyk, Phil Olter and many others—who answered my pleas for help with photos of chip-loving Better Made fans.

A final and important thank you goes to my family. You were willing taste-testers and rough draft reviewers. I appreciate your patience as I worked through this salty story.

# Oil, Salt and Potatoes

P otato chips—those salty, golden morsels that are the definition of American ingenuity—are a deceptively simple snack food.

The average potato chip bag lists three ingredients: oil, salt and potatoes. That humble tuber mixed with a handful of spice and fried at the right temperature becomes something akin to magic. They not only fill people's bellies but also put a smile on their collective faces.

For Detroit and many cities like it, potato chips provided that and so much more: jobs, name recognition and a taste that came to define home. With just three ingredients, home-based potato chip manufacturers sprang up across Detroit in the 1920s. These early chippers created a cottage industry in a bustling metropolis with a reputation for fast cars and hungry entrepreneurs.

The humble goal of earning a little pocket money expanded in the 1930s. A few dozen companies grew into commercial kitchens, where the owner's friends, neighbors and, in many cases, Detroit's increasing immigrant population worked with dexterity to fill bags with chips and staple them shut. Door-to-door hustle combined with stands in hot spots like Belle Isle also fed these fledging businesses.

By the 1940s, small kettle-cooked batches had given way to industrial fryers. Paper or wax bags were replaced with foil-lined versions that were machine sealed. The days of carrying bags of potatoes in from the truck waned as conveyor belts replaced young muscle. Women of all ages—whether they were high school graduates, single mothers or widows—worked the factory floor and in a growing number of storefronts. Men took care of the frying, worked in the

# Prologue

warehouses and delivered the finished product to the neighborhood grocers, druggists and convenience stores across the city.

A few companies transformed again into factories whose busy production lines defined the "Nifty Fifties," giving livelihoods to those men and women who needed jobs after World War II. A handful of businesses had exploded into conglomerates by the swinging '60s, establishing brands whose manufacturing might and deep distribution channels allowed them to gain dominance over the state's snack food industry.

As the decades passed, many beloved household names would go from family businesses to corporate ownership. By the 1980s, mergers, the race toward automation and competition for shelf space had driven most Detroit chippers out of existence. Their only legacy was rusted tins inside the family attic or faded advertisements painted on silos along Michigan's blue highways.

The longest-lasting company to survive those ups, downs and everything in between is Better Made Snack Foods. Its plant on Detroit's Gratiot Avenue is a landmark in this hard-luck city. People of all ages recognize its logo, which features a friendly young maid whose product is "Guest Quality"—that is, fine enough to serve anyone who might grace your doorstep.

Two distant cousins—Pete Cipriano and Cross Moceri—started Better Made with a single truck and a few hundred dollars in cash. They had a mutual devotion to excellence, personally supervising production to ensure that chips were crispy, delicate and perfect. With its impeccably fried products, Better Made set the standard among other companies. Everyone judged their chips by Better Made's color, its freshness and, most importantly, its taste.

The fact that Better Made endured from its incorporation in 1930 to today is a bit of a miracle in and of itself. Better Made fought a plethora of challenges from national potato chip companies to fickle consumers to Detroit's population woes. Its owners clashed on key aspects of the business, creating such heated debates that Cipriano would walk out of the room if Moceri came in and vice versa. When the two families finally separated through a buyout in 2003, there was a moment when it looked like the company might have reached its end.

Yet Better Made persevered. Its continued success is a testament to family pride, employee loyalty, community support and thousands of hungry fans who go out of their way to pass by rack after rack of other brands to grab that red-and-yellow bag.

Three ingredients. Salt from a Michigan mine. Cottonseed oil from American manufacturers. And locally grown potatoes for as long as the ground produces them. Those three things are found in every Better Made potato chip.

So simple and yet so complicated. And so, so Detroit.

## Chapter 1

# Potato Peddlers

*What small potatoes we all are compared with what we might be!*
*—Charles Dudley Warner*

In modern-day Detroit, the sprawling façade of the Better Made Snack Food plant serves as a focal point along Gratiot Avenue. It stands out among the churches, gas stations and neighboring houses for a variety of reasons. It is the only manufacturing facility of any kind for miles. After more than a dozen expansions, the factory takes up an entire city block from Gratiot to French Road. There is the red-and-blue "Better Made Quality" sign that stands guard at the building's front. There are its large glass windows, which give a glimpse of the sizable production lines and freshly fried chips inside. Then there is the dramatic sight of a semi-truck trailer on a hydraulic lift as it is tipped to deliver a load of forty-five thousand to eighty-five thousand pounds of potatoes.

Inside, something amazing is about to happen. In about seven minutes, those potatoes will go from a raw tuber, still coated with the earth in which it grew, to a Better Made potato chip. From that truck, potatoes pour in through a small window to the facility. They are bounced along a conveyor belt to bright-blue storage bins. This is the area where it pays to linger; the odor of soil and fresh potatoes is so strong that you will smell it long after you have left the factory. It is the kind of scent memory that moves you, reminding you of this nation's farming heritage and the goodness of eating something fresh from the ground.

# BETTER MADE IN MICHIGAN

Those potatoes selected are transported to a machine that washes the spuds to remove any field dirt or contaminants. A machine peels the outer layer off in seconds. From there, another machine slices them to a precise width. Once a Better Made employee inspects the potatoes to remove any of poor quality and ensure that they are of uniform size, they are off to a temperature-controlled cooker. They are fried in oil for about three to four minutes. A machine salts the chips while they are still hot and moist. Any flavoring, such as the seasoning for the legendary barbecue flavor, comes next. The finished product moves along an overhead vibrating conveyor system to automatic packing machines that weigh, fill and seal the bags. Workers put the bags inside cartons, which are taped shut and moved to the Better Made warehouse for distribution to grocery stores, convenience markets and other outlets across Michigan and a handful of other states.

Some 60 million pounds of potatoes go through the plant annually, producing an impressive amount of potato chips. But that's not all Better Made does. In fact, President Mark Winkelman describes the company as a "snack food distributor that makes potato chips" for good reason. Besides manufacturing chips, potato sticks and popcorn on site, Better Made creates private-label products for retailers and distributes a variety of snack foods with its labeling to stores regionally. There's corn pops, party mix, cheddar fries, cheese curls, corn chips, tortilla chips, pork rinds, cracklins, salsas, dips, rubs, licorice, beef jerky, nuts and more, all finding their way to store shelves because of Better Made's distribution prowess. It is what diversifies the company, Winkelman said, keeping it profitable beyond Detroit's sizable and notable chip obsession.

It is, without a doubt, a far different company than the one that started in the 1920s in the kitchens of Cross Moceri and Pete Cipriano. For them, the potato chip business was something they did in the cool evening hours and peddled door to door in small batches. Among their earliest customers were families picnicking in Detroit's many parks on the weekends or travelers on one of the city's streetcars during their busy daily commute. Better Made's start was so inauspicious that level-headed Cipriano remained a milkman for many years after its creation. Family lore has it that he finally gave up his route around 1941 to keep an eye on his investment in the company, which Moceri had grown into a storefront along East Forest Avenue and then into a larger kitchen along McDougall. A short-lived stay on Woodward Avenue—where the nearby secretarial pools troubled by the smell of frying potatoes would force Better Made to work only at night—would take the company to its current Gratiot Avenue location by 1949.

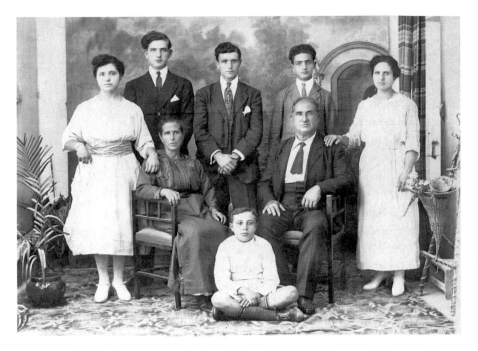

Pietro "Pete" Cipriano was one of nine children. A 1913 family portrait features six of the siblings along with Pete's beloved father and mother, Isadore and Catherine. *Cipriano family collection.*

The best way to understand the powerful legacy of Better Made and that of Detroit's "chipreneurs" is to look back at the city's development, its entrepreneurial landscape and the families who created these companies. Over the twentieth century, there is evidence that there were about forty potato chip businesses of various sizes selling potato chips in the Motor City. Most started as and remained home-based chippers, selling batches of what really were kettle-style chips. A dozen or so would become household names, including brands such as Everkrisp, Krun-Chee, Superior, Mello Krisp and Wolverine. Less than a handful developed into well-organized businesses that became regional or national players. The most notable example is New Era, the brainchild of Ernest L. Nicolay and Russell V. Dancey, two autoworkers turned potato chip titans.

Many of these chip companies, including Better Made, were started by immigrants eager for work and looking to create jobs for other newcomers from their homeland to Detroit. In the case of New Era, it was a business that grew out of the ambition of a farmer's son who wanted success that did not depend on Mother Nature. These were men who saw a city with immense

hunger, literally and figuratively. In Detroit, they could grow alongside the population, the city's towering skyscrapers and its powerful automotive manufacturers. They could take their first years of struggle, harsh working conditions and desperation and channel them into their own enterprises, many of which created fortunes that have lasted well into the second and third generations.

So where did the idea for these delicious treats start? Theories vary, but researchers have found recipes for potato chips in cookbooks from the early nineteenth century. Most potato chip historians say that the salty snack as most people know it was invented in about 1853, when Chef George Crum worked at Moon's Lake House in Saratoga Springs, New York. That tale centers on Crum dropping a thinly shaved potato in the fryer to serve to a finicky customer who had returned their potatoes for being too thick. Another version has Crum's sister, Katie, inventing what is known as a potato chip when she accidentally dropped a potato slice in the kitchen's fryer. In recent years, however, a small group of folklore historians who have studied the story have noted that a secondary chef known as Eliza was the likely inventor. She was known for "crisping potatoes," building a potato-frying reputation in Saratoga around the late 1840s. Eliza Loomis, who owned the Lake House, is the likely culprit. Loomis worked in the kitchen, as most managers would have, and there are various newspaper articles that report customers enjoying crispy potato slices there years before Crum arrived. By one account, the Lake House had built such a reputation for its chips that in 1866 it started selling them in portable paper cornucopias so visitors could take some home with them. For decades, the so-called Saratoga Chips would become a staple in area restaurants' menus, a fad item to serve as a side dish.

The transition from restaurants to commercial production likely began in the late 1890s. William Tappenden of Cleveland, Ohio, tends to receive credit for the mass production of potato chips. The Snack Food Association describes Tappenden as "a familiar figure on Cleveland's streets, delivering potato chips to neighborhood stores in his horse-drawn wagon." He is credited with opening the first potato chip factory in 1895 in a barn at the back of his house when chip demand outgrew his stovetop production. According to one source, he listed "potato chips" as his occupation in the 1900 census. Dirk Burhans, author of *Crunch!: A History of the Great American Potato Chip*, hypothesized that cities across the United States probably had salesmen like Tappenden, hawking chips to restaurants or those he passed by en route to his deliveries. Tappenden's association with an early version

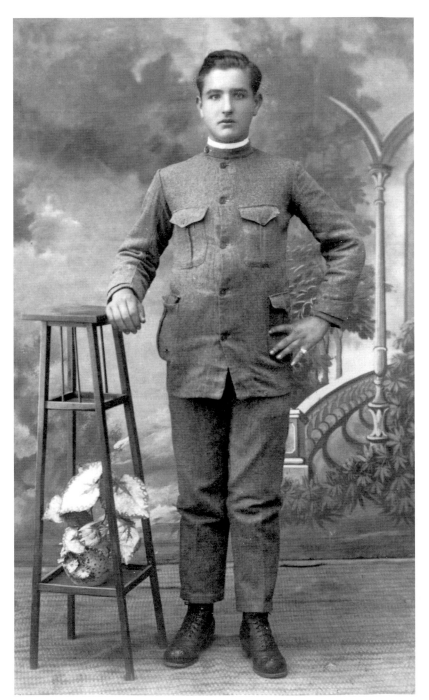

Pete Cipriano in 1918. He would have been around fourteen when this portrait was done in Terrasini, Sicily, his hometown. *Cipriano family collection.*

of the Snack Food Association also may have given rise to his name as the potato chip processing pioneer.

As their popularity grew, potato chips started showing up for sale at bakeries, confectionery stores and restaurants across the nation. There were no distributors or salesmen; all of these potato chips were made in-house and served straight from the fryer. Retailers handed them to customers in paper sacks, scooping them to order out of cracker barrels or from glass display cases. As a result, potato chip historians describe this period from the 1850s to the 1920s as the "Cracker Barrel Era." By the 1910s, Burhans wrote, "potato chips were still mostly a cottage industry; if they were not produced and consumed solely within the confines of a restaurant, they were sold within a few miles from where they were produced. Served from baskets, bins or in plain paper bags, they had little or nothing in the way of recognizable brand names, publicity or associated advertising."

Some of the first chip companies started to show up from 1910 and into the 1920s, gaining steam as the Roaring Twenties pumped up the United States. During this decade, Americans moved away from the farm in record numbers and began filling the cities. The nation's total wealth more than doubled between 1920 and 1929, creating what some called a "consumer society," where people had discretionary income and the leisure time to enjoy it. They bought ready-to-wear clothing, enjoyed the first versions of household appliances and cranked up their radios for entertainment. A little station called 8MK in Detroit broadcast the first radio-news program on August 31, 1920—it is known today as all-news station WWJ-AM 950. Americans also became enamored of movie houses and watching films; by the end of the 1920s, an estimated three-fourths of the U.S. population is said to have visited a movie theater on a weekly basis.

Detroit was a city on the rise as well, building fast and high. Some of its greatest architectural accomplishments came during that decade, filling the city's horizon. There is the dramatic Book-Cadillac Hotel, which had more than 1,200 guest rooms within thirty-three stories, making it the largest hotel in the world when it opened in 1924. The Penobscot Building, with its impressive forty-seven stories, stood as the eighth-tallest building in the world upon its completion in 1928. Other monumental facilities came online during that decade, making Detroit a city known for transportation of all kinds. In November 1929, the Ambassador Bridge was opened to traffic. And the Detroit-Windsor tunnel was just months away from completion, opening in November 1930. "Flush with money, confidence, optimism and civic pride, [Detroiters] embarked on a building spree—hotels, schools,

Signing as "Peter Cipriano," the Better Made co-founder became a U.S. citizen on December 23, 1935. The certificate lists him as thirty-one years old with a medium complexion, blue eyes, brown hair and a height of five feet, eight inches. *Cipriano family collection.*

clubhouses, office towers, airports, factories, golf courses, tunnels, libraries, music halls, theaters, subdivisions, an international bridge and a stadium—that was surpassed by only New York and Chicago during this period," according to author Richard Bak.

Detroit also had become an epicenter for immigrants looking for jobs and a chance at the American dream. "Detroit's foreign-born population numbered more than 156,000 in 1910, a figure that doubled within 10 years. In 1925, roughly half of the city's 1,242,044 residents had been born outside of the United States, the largest percentage of any city in the country. These included 115,069 Poles, 49,427 Russians and 42,457 Italians," Bak wrote. Between the years of 1920 and 1929, Detroit added more than 500,000 people to its population. By the end of that decade, an estimated 30 percent of its residents were working in factories, mostly within the automotive industry.

# BETTER MADE IN MICHIGAN

The demand for products from those factories was so great that Detroit advertised for workers throughout the United States, promising high wages to anyone who would pack up and move. During this time, the city's size expanded to accommodate these new residents, going from 83.0 square miles in 1920 to 139.6 square miles by 1926. When Cross Moceri arrived in 1910, Detroit's population was 465,755 people. When Peter Cipriano came about ten years later, that number had increased to nearly 1 million.

Both Moceri and Cipriano came to the United States from Terrasini, a small city on the island of Sicily located about nineteen miles west of Palermo between the mountains and the Gulf of Castellammare. Its name, which in Latin means "terra sinus" or "land at the gulf," is said to have been inspired by the strongly curved coastline. Although Terrasini's blue waters must have been difficult to leave, there were no jobs and no future for young men in the area, given the devastation caused by World War I as well as regular drought conditions, said Sal Cipriano, Pete Cipriano's son. By 1920, some 4 million Italians had come to the United States, accounting for an estimated 10 percent of the country's foreign-born population. "There was no work in Terrasini; the economy was terrible," Sal Cipriano said. "America was the promised land. There was industry here: cars, railroad cars, cast-iron stoves. You name it. The jobs and the opportunities were here."

Cross Moceri was born on May 13, 1898. He sailed from Palermo in March 1910, when he was about twelve years old. His passport application, which lists his father as Giuseppe Moceri, shows that he arrived in Detroit a few months later. Census records from the decade following reveal that Moceri held a variety of jobs, including streetcar conductor. According to U.S. Census records, Moceri was married at age twenty-three to Rosa, then eighteen. He is listed as a widower in the 1930 census with a seven-year-old son, Joseph. Moceri gained his citizenship in June 1921, a few months before Cipriano arrived.

Pietro "Pete" Cipriano was born on April 12, 1904. Cipriano, whose father is listed as Isadore Cipriano, was one of nine children; his siblings included Vincent, Jerome, Rose, Sal, Isidore, Joseph, Grace and Constance. He, too, had limited education; U.S. Census records note that he completed a sixth-grade education. According to family lore, Cipriano always loved to eat and arguably was the best chef in the house. "When he was in Italy, and his mother made steak and potatoes for family, he'd try to trade his steak for his sisters' potatoes. He loved potatoes," Sal Cipriano recalled. "When we were older, we used to have those Sunday dinners when everybody came over. He just loved to cook."

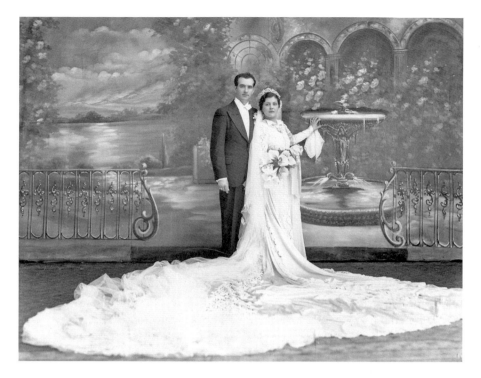

The wedding portrait of Peter and Nicolina "Evelyn" Tocco Cipriano displays her ornate wedding dress and flowers. The two, who both grew up in Terrasini, married in 1937. *Cipriano family collection.*

At age seventeen, Cipriano sailed out of Palermo with his brother Jerome as a companion across the Atlantic Ocean on the SS *Patri*. The French ocean liner—which received its name from the Latin word *patria*, or "fatherland"— was an impressive vessel, with seven decks, direction-finding equipment and a cinema. Cathy Gusmano, Pete Cipriano's daughter, said that her father's only story from his arrival in New York was visiting the Statue of Liberty. Little did Cipriano know then that his decision to leave Sicily meant that he would never see his father again. "His brothers were already here, so he came and stayed with them. They were used to that at the time; they were always taking in relatives," Gusmano said.

Vincent Cipriano and his wife, Rose, were getting by on his wages from working at a fruit stand in the area, Gusmano said. Jerome, Pete's traveling companion, soon found a job as a milkman, and Pete joined him. The 1930 U.S. Census lists Pete as "working for self" with a milk wagon; he likely was a milk peddler or an independent milk salesman. Milk peddlers delivered their goods on foot or by horse-drawn wagons, selling directly to Detroit

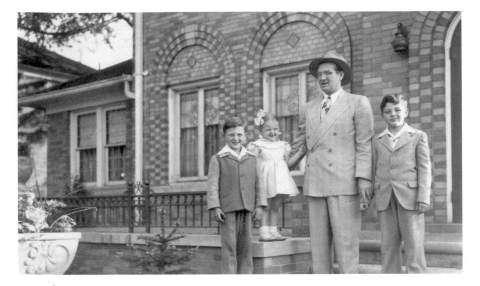

In this 1946 photo, Salvatore (left), Cathy, Pete and Isidore stand in front of their grandfather's home at 1445 Grayton in Grosse Pointe Park, where they lived until Cathy was thirteen. *Cipriano family collection.*

households. Larger groups soon sprang up; these co-called milk dealers hired deliverymen to bring milk from the area's creameries to Detroit's grocers, restaurants and neighborhood stores.

Meanwhile, a friendship forged in a Detroit-area automotive factory would give rise to another pair of chippers. They were lured to Detroit by the city's promise, the automotive industry's relatively high wages and the fact that there was nothing holding them in their respective hometowns. Chance placed Ernest L. Nicolay and Russell V. Dancey side by side inside the massive Dodge Main auto plant in Hamtramck. Their lunchtime conversations revealed their similar childhoods, inquisitive natures and entrepreneurial drives. Those chats combined with a sense of compassion for their fellow man would push the duo of Nicolay and Dancey into a business that would make them friends and business partners for the next twenty-five years.

Ernest Lowell Nicolay was born on July 14, 1899, the son of Columbus Edwin Nicolay and Barbara Mariah Nicolay. He was one of ten children in a family of three boys and seven girls. His father died when he was only three years old, leaving Ernest as the next to youngest sibling. According to family lore, Columbus Nicolay's death left his widow with a rented farm and equipment with outstanding bills. Barbara and her two oldest

sons, ages twelve and fourteen, kept the farm operating for the next seven years until she moved to Manhattan, Kansas, when Ernest was ten years old. Ernest stayed behind with his two older brothers to help with chores, including milking the farm's ten cows before walking to school. Nicolay enrolled in college in Manhattan, Kansas, living in a student boardinghouse where he washed dishes for three dollars per week and to cover his rent. He is said to have left college to serve in the military, after which he attempted to start a variety of businesses, all of which failed. Nicolay was in Detroit visiting his sister and her husband when a relative found him a job in the Dodge auto plant.

Russell Victor Dancey was born on May 14, 1904, to Frank A. and Anna B. Dancey. The Dancey family, which included seven boys and one girl, lived in Effingham, Illinois. From the start, Dancey understood the power of hard work—he earned five dollars monthly to help with the family bills by herding cows on several neighbors' farms from one pasture to another on a daily basis. By age fourteen, Dancey was a butcher's delivery boy, making

One of Pete Cipriano's favorite pastimes was fishing. This 1948 photo shows him enjoying a warm summer day with a full line of fish. *Cipriano family collection.*

the rounds to customers who would include his future wife, Opal Luvina Utterbeck. Dancey soon advanced to sausage stuffer, lard renderer and, eventually, butcher. It is said that he also held down jobs as a newspaper delivery boy and pin setter for a bowling alley.

Betty Dancey Godard, the only child of Russell and Opal Dancey, said that her father also excelled at baseball, earning a partial scholarship to the University of Illinois for athletics. However, his parents were unable to help him afford the rest of his expenses, so Dancey could not accept the scholarship, Godard said. He so desperately wanted to attend college that he went to several area banks and applied for a loan to cover the costs. The banks turned him down, however, telling Dancey that they had no way of knowing whether his fortunes would improve to the point that he could pay them back in a timely fashion. Dancey came to Detroit in about 1923 at the behest of several of his brothers; they were working in automotive plants and saw the potential for good fortune there. Dancey arrived with plans to complete college while he was working. Fate, however, never allowed him to fulfill his dream.

Opal and Russell were high school sweethearts, and even his move to Michigan could not keep them apart, Betty Dancey Godard said. "When he left to go to Detroit, they had a promise. My mother was only seventeen. He said, 'Well, I'll come back, and we'll be married on Memorial Day weekend 1924.' My mother said OK, thinking it would be the last she ever saw of him. When he came back, he called her and he said, 'Do you know what tomorrow is? It's our wedding day,'" Godard said. "It was a very successful marriage; it lasted fifty-plus years. She was the light of his life."

Godard said that her father always had what some might call the "gift of gab," giving him the ability to talk to anyone. At Dodge, the outgoing Dancey met Nicolay on the factory floor, and the two began to discuss their aspirations. Despite Nicolay's quiet nature, the two clicked immediately, Godard said. According to one newspaper account, "The two discovered they shared a common love for the soil and for hard work and conscientious service."

"One day, they said, 'You know we're never going to get any place in life if we don't own our business.' At lunchtime, they'd sit down and read the classified ads in the newspaper," looking for part-time or other business opportunities, Godard said.

Nicolay and Dancey began with shoestring potatoes, which they could make after work and sell to people on Detroit streetcars. Although they had hustle, the payback from this work was limited. So, the duo approached a

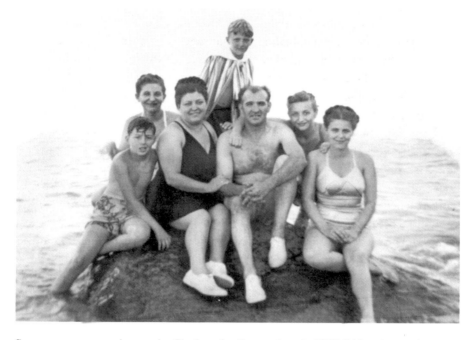

Summer meant vacations to the Cipriano family, seen here in 1957. Isidore is seated to his mother's right, Salvatore is above his parents and three of Pete and Evelyn's nieces are present. *Cipriano family collection.*

bank for a loan to purchase a candied popcorn machine and a peanut roaster. They even had a factory foreman involved as an investor. But their idea fell through when Dodge began laying off people at the factory in 1926. Godard said that the department manager walked down the line laying men off. Nicolay got cut. Dancey did not.

"The fella next to my dad was a young German man with five kids. My dad stepped up and offered his position. He said the young man had five kids, but my dad only had one," Godard recalled. "That's when [Nicolay and Dancey] started their business in earnest because it became their bread and butter."

That Christmas likely was a bit sparse for young Betty Godard. But that soon would change. Dancey, who took charge of the fledgling company's sales and advertising, sold enough popcorn and related goods to keep cashing flowing. In about 1929, the small firm of Nicolay-Dancey Company purchased the equipment necessary for making potato chips. Nicolay took over production and in-house issues, while Dancey began calling on customers. Godard said one of their first victories came from the Dodge company.

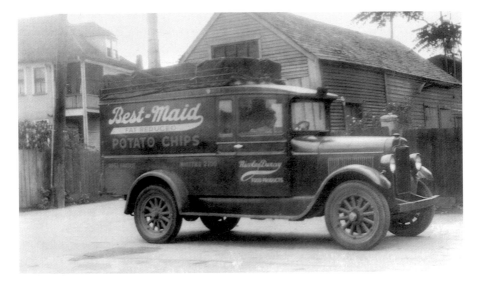

This picture of a Best Maid vehicle, which belonged to Cross Moceri, hangs in the Better Made offices. It is an homage to the truck that was the foundation for the potato chip company. Best-Maid was the original name of New Era; Moceri is said to have worked there as a salesman. *Better Made archives.*

"My father called on him, and [the purchasing manager] gave him an order for more potato chips in a week than they had made in three months," Godard recalled. "So, my dad invited him to visit their factory, which was at the corner of Cadillac and Warren in a little shop. One morning, that purchasing manager walked in. He saw the process they had with the fryers and the two young female employees who were making the potato chips. He was so impressed that he became one of my father's mentors, introducing him at all of the important clubs of the time, asking anyone if they would be interested in buying some really good potato chips."

That shop at 10108 East Warren Avenue at Cadillac Avenue was growing so fast that it would need a name and a salesman who could help Dancey with his growing duties. The duo came up with what they thought was the perfect description: "Best Maid." As for that new hire, they found a young, aggressive Detroiter who seemed eager to help them build their potato chip dynasty.

His name was Cross Moceri.

*Chapter 2*

# Seeds of Growth

*You like potato and I like potahto. You like tomato and I like tomahto. Potato, potahto, tomato, tomahto. Let's call the whole thing off!*

—*Ira Gershwin*

**T**here are many versions of the story of how a young Cross Moceri came to work at Best Maid, arguably the first organized potato chip manufacturer in the city of Detroit.

The way that Sal Cipriano tells it, Moceri was a salesman for Nicolay and Dancey. Moceri had a truck with the Best Maid logo on it that he used for deliveries. The Ciprianos say that Moceri's truck and their father's initial cash investment were the foundation that started their chip company. In fact, a picture of the Best Maid truck hangs proudly in Better Made's offices. "My dad's cousin was in the chip business with a company called Best Maid, and they split up. One became New Era. Then, [Moceri] got a hold of my dad and said, 'Let's go into business together, and we'll change the name to Better Made,'" Sal said.

Betty Dancey Godard, daughter of New Era co-founder Russell V. Dancey, tells another tale entirely. "My dad went on vacation, and when he returned, he found out that one of his best salesmen absconded with the merchandise and the truck," Godard said. "[Moceri] rebagged the potato chips and called them 'Better Made.' Best Maid had to change its name because of it."

A third iteration, from a potato chip historian, notes that Moceri left an unnamed chip manufacturer to start Better Made when the company denied

Cross Moceri and his second wife, Mary, were frequent travelers and enjoyed visiting family around the globe. *Daniels family collection.*

him a commission. In another version, this time from two Better Made veterans, Moceri started a chip company on his own before he approached several different people for a loan to get the business off the ground. In that story, Moceri first went to friend Joe Leone for the money; Leone also was from his hometown in Sicily. However, Leone did not have that kind of cash and was unable to help. That is when Moceri approached Cipriano. With his family's advice, Cipriano asked to receive a 50 percent share of the business to cover his loan.

On the Moceri side, two of his relatives, Joseph Moceri and David Daniels, said that Cross Moceri wanted to expand his personal potato chip company. He needed an investor and approached Cipriano for a loan. Daniels said he

understood from family lore that Moceri started his chipping business in part as an investment and to support his sister, who was helping him raise his son, Joe. Moceri's first wife had passed away at a young age, and Joe spent most of his time with his aunt and cousins. Daniels said that Joe considered his cousins to be his siblings because the relationship was so close.

So how did Moceri and Cipriano come to start a potato chip dynasty? The truth is probably somewhere in between. One thing is for sure: there

Cross and Mary Moceri entertained family and friends at their Grosse Pointe Shores home. *Daniels family collection.*

was a Best Maid before there was a Better Made. Telephone directories of that era show that the Nicolay-Dancey Company first sold its chips under the Best Maid name; it is the sole brand listed for about two years. By the time Cross & Peters appears in Polk's Detroit City directories, around 1931, Nicolay-Dancey has both Best Maid and New Era listed as its primary brands. Another phone book lists its shoestring business by the name Shoe String Taters. By the mid-1930s, the Best Maid moniker had disappeared entirely from the Nicolay-Dancey entry. When you look at side-by-side comparisons of the two logos, it is hard to deny the similarities between these two competing companies. Both logos are rectangular with the name prominently displayed. Both initially used a hyphen (Best-Maid and Better-Made). Both have the words "potato chips" within a line that connects to the final letter in their brand name and swoops below their name. Within that underline, Best Maid notes that its chips are "Starch Reduced," while Better Made's are "Fat & Starch Reduced."

One has to chuckle a bit at the moxie of two young men when they selected "Better Made" as their brand. It is quite a boast. Yet it makes perfect sense for several reasons. The first is because both founders were what some might call food connoisseurs. Family members say that their attention to detail and pride in their potato chips were second to none. For example, to get the best crunch, Moceri sliced his potatoes to the width of a dime, using the coin as his measuring stick, Joseph Moceri said. These young entrepreneurs hoped to separate themselves from the competition by using only what they considered to be the best products on the market. That included farm-fresh potatoes, Michigan salt and 100 percent cottonseed oil. "You had to get the right potatoes. Those days, [other chippers] didn't know one potato from another. We were ahead of everybody because we were using white potatoes. Everyone else was using Russet," Joseph Moceri said. Cottonseed oil also was a deliberate choice, said Isidore Cipriano, Pete Cipriano's firstborn son, a retired Better Made employee and a company board member. Not only is cottonseed oil virtually tasteless, it has a low melting point similar to that of a person's 98.7-degree body temperature. This allows the oil to dissipate when you eat a Better Made chip, letting the potato flavor shine through.

The second reason why potato chip businesses wanted to promote their quality was related to food sanitation and product freshness. Both were significant issues for these fledgling companies. Although these brand names might seem a bit arrogant, they also were artful ways of reassuring the public that they were eating high-quality chips that would not get them sick afterward. Making potato chips may seem easy, but it quickly becomes difficult if you fail to pay

attention to the small details. And there are a lot of small details. Having large quantities of food on site attracts bugs and vermin. Oil and potatoes have limited shelf lives. Early attempts at storing potatoes for later use had limited success; customers accustomed to snow-white chips made from fresh potatoes complained when their chips made from stored spuds seemed mottled or tasteless. Once cooked, the potato chips could become rancid if exposed to light for too long; the industry eventually accounted for this by switching to opaque packaging. Stapling the bags shut—a common practice long into the 1940s— only kept the finished product crisp for so long, making oily or stale chips another regular complaint.

In 1930, Moceri and Cipriano made it official. The company's Articles of Agreement for Co-Partnership with the State of Michigan set the birthdate of Cross & Peters as August 1, 1930. That is when Moceri and Cipriano "agreed to become co-partners in business…under

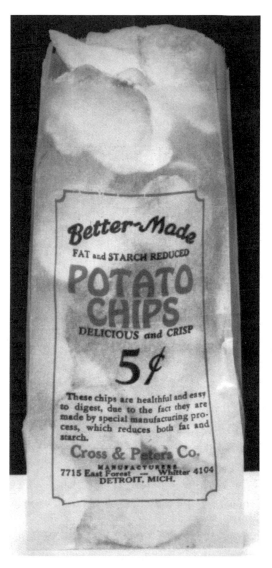

The first Better Made bags show a hyphen and a cursive-style logo, which bears a strong similarity to the Best-Maid brand. *Better Made archives.*

the firm and partnership name of Cross & Peters Company in the business of manufacturing and selling potato chips." The agreement was binding for five years. It gave one half to Moceri and the other half to Cipriano; it was a fifty-fifty partnership, straight down the line. All profits, bills and the like were to be

"share and share alike," according to the agreement. The new partners were to meet every two weeks on the fifteenth and thirtieth to discuss any company business, revenues or losses.

It is more likely that Better Made got its start somewhere between 1926 and 1929, when Moceri and Cipriano began working together based on a handshake and a verbal agreement, according to multiple sources. But for all intents and purposes, that August 1, 1930 date serves as the official launch of Better Made as a going concern. To this day, every Better Made bag honors 1930 as its founding year both in the company's logo and in the story about the chip company's origins on the back.

On July 31, 1934, Cross & Peters registered the Better Made brand with the State of Michigan. That document, stored within a plain gray filing cabinet in Sal Cipriano's office, includes one of Better Made's first bags. It is a brown, waxy container with "Better-Made Potato Chips" written on the front along with a red five-cent price tag. The text is rounded and highly stylized, set in what looks like an Art Deco typeface. After its brand name and price, the bag promises hungry consumers that the chips found within are "delicious and crisp." A small grid-like pattern along the bag's sides is the only hint of the iconic lattice that soon would be found on every bag of "Original" Better Made potato chips.

The brand's appearance slowly evolved in the decades to come. The hyphen that once connected the Better Made name disappeared within a few years—there is no explanation as to why it was dropped. The maid that is synonymous with Better Made also showed up sometime later. Family lore also has it that Cipriano created the cartoon of the winsome maid, drawing her while sitting at his kitchen table. Cathy Gusmano said that there have been attempts to modernize or "sex up" the maid, but she has vigorously fought to maintain the character and keep her as close to what her father originally intended.

A maid of another sort came into Cipriano's life in the mid-1930s. Nicolina "Evelyn" Tocco, born on February 5, 1915, immigrated to the United States when she was thirteen years old. Her father, Salvatore, was the first to come to the country; his 1922 passport lists him as a laborer. Young Nicolina and her brothers lived with her mother, Antonina Zerilli, and grandmother in Terrasini until the family could bring everyone to Detroit in June 1928. Pete Cipriano knew Evelyn's family both in Sicily and Detroit, but he was about a decade older than her. "He used to joke that he was waiting for her to grow up so he could marry her," Sal Cipriano said. Pete and Evelyn tied the knot in 1937 when Evelyn was twenty-two and Pete was thirty-three. Gusmano described

Moceri and Peter Cipriano
do hereby declare that the................label, design and/or form of advertisement,
(Insert the word Label, Trademark, Term, Design, Device or Form of Advertisement, as the case may be.)
counterparts or facsimiles of which are filed herewith is filed on behalf of Cross Moceri and Peter
Cipriano, co-partners doing business under the name and style of
Cross and Peters Company,...............

that the particular class of merchandise and a particular description of the goods to which it has been or is
intended to be appropriated is.............prepared potato chips,

that the said.......Cross and Peters Company
has the right to the use of the same and that no other person, firm, association, union or corporation has the
right to such use, either in the identical form, or in any such near resemblance thereto as may be calculated
to deceive, and that the facsimile copies or counterparts filed herewith are true and correct.

Cross Moceri

STATE OF ....MICHIGAN
County of....WAYNE }ss.
On this........31st........day of........July........A. D. 19.4.
before me a....Notary Public................, personally appeared the above named
Cross Moceri
statement by him subscribed is true.

Caroline Zwicker
Notary Public, Wayne County, Michigan.
My commission expires....02/18/193.7.

*If a person, insert name; if a member of a company or firm, insert name and add the words "a member of the firm or co-partnership
doing business under the name and style of," then give the company name, and add "composed of" giving names of the members; if an
officer of an association, corporation, or union insert name, title of office and name of the association, corporation or union.

In 1934, Cross & Peters trademarked its potato chip company's brand name. The "NRA" blue eagle at the bag's top showed that the company supported the National Recovery Administration, which sought to limit competition and help workers by setting minimum wages and maximum working hours. *Better Made archives.*

her mother as a classic Sicilian woman—a loving caregiver who tended to her ailing mother and watched the kids while her father went to work.

There was plenty of work to be had. When Cross and Peters got into business, they made chips in a basement or their garage. In 1930, Moceri

was living at 2675 Lemay Avenue, and Cipriano was at 3265 Fort Street. But as demand grew, they set up shop in a commercial-style kitchen. "They made them in the back, selling them for a nickel a bag on the weekends. As they got bigger, they grew into other buildings," Sal Cipriano said. By 1931, they had established themselves at 7715 East Forest Avenue. They would size up again in 1932, going to 5502 McDougall Avenue. The company would remain there until the 1940s. The McDougall location was where the company first started making real money, Joseph Moceri said, encouraging Moceri to buy more equipment to cook even larger batches.

Russ Leone, whom friends describe as "a Better Made man from the beginning," said that his father, Joe, took him to the McDougall facility every weekend. Joe Leone served as Better Made's plant manager from about 1934 forward, and his son followed in his father's footsteps to be a Better Made employee for more than fifty years. "My dad used to work on Saturdays, and it was a real treat to go to work with him. If I went in with him and helped out, I'd always get a big glass of chocolate milk as payment," Leone said. "Everybody [today] talks about kettle-style chips. Well, back in the 1930s, everything they made was a kettle chip, period. I can remember using a net to scoop out the chip from the hot oil. They'd spread them out on a table, salt them and then put them in the cans."

Making potato chips was a labor-intensive process in those years. Phil Amigoni, who worked at Wolverine before joining Better Made, helped unload the potatoes from the trucks for an extra two cents per bag. "I'd fry for a while, and then a truck would come in. I'd get someone to cover me, and then I'd run to unload the potatoes," Amigoni said. "The truck would pull up on the sidewalk on the street. There was a chute from the truck to the plant. The guy would throw the one-hundred-pound bags of potatoes down that chute, and we'd stack them up eight high in the basement."

George Orris, who worked at Krun-Chee, said that unloading the potatoes was among the worst jobs in the factory. It could take hours to unload a truck. Orris said most of the potatoes came from out-of-state growers; Michigan was not yet a major spud producer because it had yet to figure out long-term storage for these temperamental products. Orris recalled how many of the potatoes Krun-Chee used came from North Dakota, where they moved their potatoes straight from the ground into caves. When the potatoes arrived at the factory, they'd be in crates and would need to be transferred to a hopper. That hopper fed the slicer and tumbler, where they were washed and air-dried before going into the cooker. "You were supposed to untie the bags to dump out the potatoes and then save the bags.

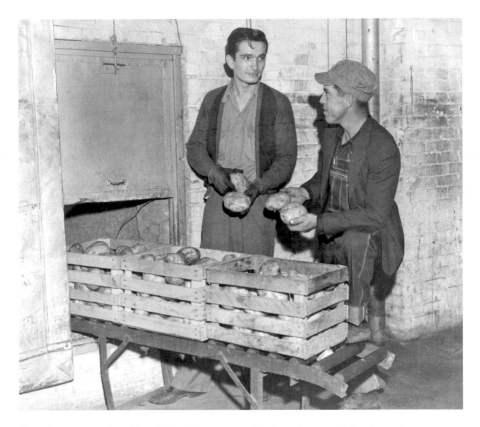

Carrying potatoes into Detroit's earliest potato chip factories was a labor-intensive process made easier only when companies started to invest in conveyor systems like this one. *Amigoni family collection.*

You'd pull on the string and then dump the potatoes into the machines," Orris said. "Once in a while, the guys would get lazy and take a knife [to the bag] and split them. But they'd get their butts chewed out because [the company] would get two to three cents per bag if they returned them."

This batch process was slow and tedious, Berhans said. "Although many chip companies started out with cast-iron kettles in the kitchen, by the 1920s and 1930s 'kettles' were rectangular cookers with capacities of 40 pounds per hour, 120 pounds per hour at the most. By 1929, all potato chips were still made via this batch process, one lot at a time—taking anywhere from five to ten minutes. The only way to increase production was to increase the number of kettles." Similarly, seasoning the chips remained a hands-on affair for many decades, salting the chips after they were spread onto a tabletop. As flavors and tumblers came into play in the late 1950s and 1960s,

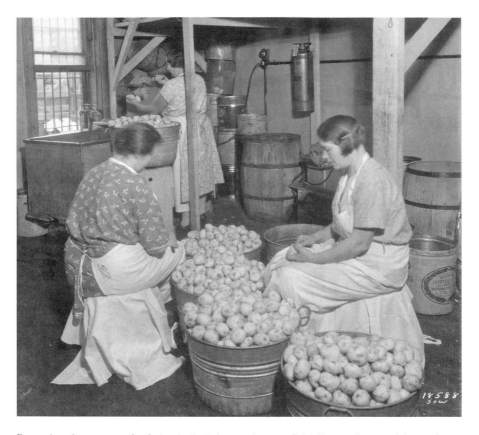

Preparing the potatoes for frying included removing any field dirt, peeling, washing and inspecting them for imperfections. *Amigoni family collection.*

employees threw handfuls of salt or seasonings into the machines, which looked like cement mixers. "After the chips were fried, they'd come down a conveyor to a funnel. They'd be funneled down to a scale, where a girl would weight it, dump it into the bag and shake it," Orris said. "She'd hand it to another girl, who would close it up and put two staples into it."

Women were a significant part of the workforce at these fledging chip factories. Known collectively as "the Girls," these women ran the chip-making process from the fryer to the final packaged product. Some of the women were war widows; most were single and came to the factory straight out of school. The tradition of having a female-dominant workforce continues even to today. *Crunch!* author Burhans said that he visited more than a dozen modern-day chip companies to research his book, and he noticed a high number of women working in these plants as well. He surmised that this

may occur because some of the female employees may have moved in and out of the workforce, and their opportunities for skilled jobs may be limited. As a result, potato chip companies are an ideal way to find steady work that may not require as high a level of training as other jobs.

With this unique mix of male-to-female workers, it's no surprise that many marriages came out of these factories. Some began right at the doorstep. For example, Amigoni said he met his wife while he was at Wolverine. "Betty used to live across the street. People would say, 'There goes Legs Newman!' She and her brothers and sisters used to come over, and I'd open a window near where the potato chips come down. They had a big family—something like seven or eight kids. They'd take turns coming over for chips. They'd take them home to their porch and eat them," Amigoni recalled. "Later on, I got her a job working at Wolverine in the afternoons, helping pack the boxes."

Like one might visit a nearby bakery, people living along some of Detroit's larger corridors—including Gratiot, Warren, Conant, McDougall, Warren, Michigan, Ford and McNichols—could walk down the street to exchange a nickel for a warm bag of chips. Starting a potato chip company was a relatively inexpensive enterprise. All you needed was a bag of potatoes, a heavy-duty pot or kettle, some oil, a lot of salt and plenty of bags, and you were in business. Most would remain home-based chippers, selling small batches to neighbors and the like. But some brands in addition to New Era and Better Made had small factories by decade's end, including Everkrisp, Krun-Chee, Vita-Boy, Paradise and Wolverine.

To stand out, these early companies tried a variety of methods to earn loyalty from customers. Most of them sponsored sports teams—for example, Better Made sponsored a championship-level softball team in 1935, said longtime Better Made controller Dave Pieper. Its players were so good that they were poached by other companies who could afford to pay them more, Pieper recalled. Other brands had decades-long relationships with bowling leagues. Wolverine Potato Chip Company sponsored multiple teams to make sure its name was front and center at all of the city's bowling alleys, said Amigoni.

Wolverine, whose motto was "Pick of the Field," also was among the first to create co-branded and private-label merchandise to draw in grocery store customers, Amigoni said. "To establish our business, we'd put the store's name on the bag. We'd leave the top plain. You'd generate more business with the name on there," Amigoni said.

Longtime chippers agree that Better Made separated itself from the pack early on by setting up in regular locations and, later in the decade, Better

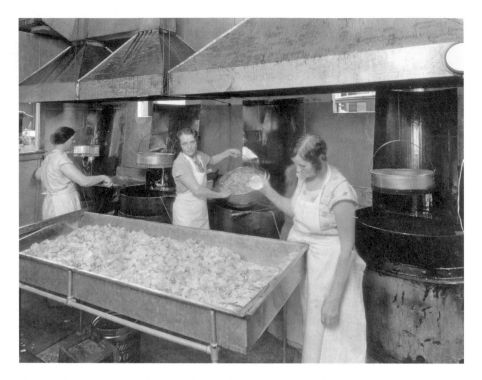

Potato chip company employees had a hand in every portion of the manufacturing process, including hand-salting the chips fresh from the fryer. *Amigoni family collection.*

Made storefronts. Drivers brought chips over from the factory to fill the shelves at these retail locations. Its branches included shops at 4846 East Davison Avenue, 8225 Harper Avenue, 9235 Jos Campau Avenue, 13321 Jefferson Avenue and 12141 Conant Avenue. Many of these locations were next door to movie theaters, allowing patrons to buy snacks before entering the show. Generally, theaters did not have concession stands then, so lots of hungry patrons at theaters like the Roxy, Cinderella and the Senate enjoyed having a chip store next door. This also put the Better Made brand in front of large numbers of consumers on a regular basis, creating buzz among Detroiters. The stores enjoyed neighborhood foot traffic as well as travelers looking to take home a bag or two for the family.

Joseph Moceri, one of Cross Moceri's nephews, started working at Better Made when he was about eight years old. He remained a part of the company until the Ciprianos purchased it. His first job was as a watchdog on the delivery trucks, making sure no one stole the merchandise when deliveries were being made, Joseph said. He remembered selling Better Made chips

THE SALTY STORY OF DETROIT'S BEST CHIP

across Detroit, including at hot spots like Greenfield's Restaurant. "It was where everyone went to lunch," Joseph Moceri said. He sold to houses, going door to door. He sold to fruit markets. He even sold a fair share to church picnics, going to busy locations where churches met after their services to catch families there enjoying the afternoon together.

The McDougall kitchen where Cross & Peters worked is said to have been next door to a bar, and its patrons, like many across Detroit, wanted something salty to munch while they drank. Potato chips became classic bar fare from the start. Chippers like Better Made delivered tins or canisters of their products to these establishments while the chips were fresh from the fryer. Bartenders transferred the chips to large glass containers, which were prominently displayed either on the bar or just behind it. "We'd make three-pound cans just for the bars," Amigoni said. "We'd ship them to the bars, and they would dump them into those glass containers. The bartender would scoop the chips, and the guys at the bar got fresh chips all day."

Yes, potato chips found their way next to a cold beer even during Prohibition, a nationwide constitutional ban on the sale, production, importation and transportation of alcoholic beverages that ran from 1920 to 1933. Detroit was a particular hotbed of rumrunning and illegal smuggling because of its proximity to the Detroit River and Windsor, Canada, where alcoholic drinks were not illegal. Godard said that Nicolay-Dancey made it through those extreme economic times in part because her father had street sense. "[New Era] grew during the Depression and Prohibition because my dad knew where every speakeasy was. He delivered potato chips to them," Godard said. "But he was honor-bound not to inform anyone. And it's probably good for his health that he didn't."

The rapid increase in the number of chip makers comes due in large part to the Great Depression, which swept across the nation from 1929 until about 1939, leaving poverty and economic collapse in its wake. By January 1932, Detroit's unemployment rate of 50 percent was double that of the national average. Some 300,000 Detroit workers had lost their jobs. With Detroit's car-centric economic core, author Richard Bak noted that the city's "pain was especially acute during the severe economic depression that gripped the country during the 1930s. Auto production plunged from 5.3 million in 1929 to a mere 1.3 million in 1931, creating unprecedented social anguish and upheaval, especially among the working class."

The same entrepreneurial burst that fueled Detroit's chippers was happening around the United States. Ohio had a significant upswing in chip companies in addition to the earliest pioneers like Utz and Wise in

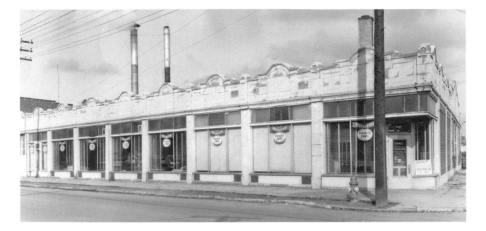

Phil Amigoni, Better Made's longtime plant manager, started his career at the Wolverine Potato Chip Company plant in Detroit. Its motto was "Pick of the Field." *Amigoni family collection.*

Pennsylvania and Japp's in Chicago (the company had to drop the founder's last name during World War II to become Jay's). Harvey Noss, a sales manager at his family's business, the Num Num Food Company, saw the potential to organize these companies into a larger group and launched the Ohio Chip Association. By 1937, the group was renamed the National Potato Chip Institute as Noss added Michigan companies to his roster, including Cross & Peters.

A number of inventions also sparked an increase in the number of potato chip companies. For example, the J.D. Ferry Company of Harrisburg, Pennsylvania, created the first continuous potato chip cooker in 1929. This machine carried uncooked potato slices through hot oil via a system of paddles, shortening the cooking time to three to four minutes. "No longer did potato chips need to be cooked by the batch; like Henry Ford's cars, they were ready to enter the era of mass production," Burhans wrote. In California, potato chip company owner Laura Scudder had perfected wax seals on potato chip bags by the late 1920s, keeping chips fresher. Sealed bags also eliminated the need for a middleman to dish them out to customers from behind the counter. In 1933, Dixie Wax Paper Company created a preprinted waxed glassine bag, which allowed companies to customize their bags with their names or that of their customers.

The 1930s also saw the rise of two snack food entrepreneurs: Herman W. Lay and C.E. Doolin. Herman Warden Lay, who was born in 1909, was what one could call a born salesman. In an essay he penned for

# The Salty Story of Detroit's Best Chip

*The Book of Entrepreneurs' Wisdom*, Lay wrote that he came by his talents naturally. His father was an expert at selling farm machinery—a feat that was particularly impressive considering he worked in an era where horses were valued beyond horsepower, Lay noted. Young Herman opened his first business when he was about ten years old, selling soft drinks from his front yard, which faced the baseball field in Greenville, South Carolina. Lay undercut the nearby stadium by selling his drinks for five cents, or half of what they were inside. "Business was so good that he opened a bank account, bought a bicycle and hired assistants to tend the stand," noted a December 7, 1982 *New York Times* article.

Lay spent two years at Furman University only to drop out for a series of short-lived jobs, including a stint at Sunshine Biscuit Company. As multiple versions of the story goes, it was the summer of 1932 when Lay heard of an opening for a route salesman at Barrett Food Company, manufacturer of Gardner's Potato Chips in Atlanta, Georgia. He interviewed for Barrett's job, but he turned it down; he decided that there was no future in potato chips. This was even after he said that he had written more than two hundred letters to other companies in the hopes of finding a sales gig. "I wanted to be a salesman, all right, but the idea of driving a truck from store to store selling potato chips wasn't my idea of a job. It just wasn't 'good enough' for me," Lay wrote in his essay.

A week later and with no other prospects in sight, Lay said that he came back to Barrett. The company made the twenty-two-year-old Lay an "extra" salesman or route helper and sent him out to hawk wherever he could. That meant schools, hospitals, roadside stands, grocery stops, gasoline stations, soda shops and anything else that came his way. Soon enough, he took over its Nashville distributor route. "I would get a weekly allotment of potato chips and a cash allowance. There was no salary, just the advance against whatever commissions I earned on sales. The territory would be in northern Tennessee and southern Kentucky, including the city of Nashville," Lay wrote. "I kept telling myself it was my territory and my business. This sense of independence kept me working. Out in the morning and on the road, all day, half the night, sleep where I was, and go again."

In 1938, Lay wrote that he saw his first continuous production line for making potato chips. It was then that he realized that if he failed to change with the times, he would fail as a businessman. "In business, if you aren't on the alert all the time, somebody will come along and get ahead of you. He will make a better product, make it cheaper, cut a fraction off selling cost, develop a fraction faster distribution, figure a fraction into the profits,"

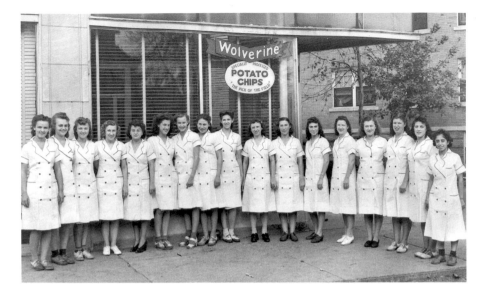

Many potato chip plants had a sizable female employee base. "The Girls" were responsible for everything from checking the quality of the newly washed potatoes to weighing the finished product to stapling the bags shut when the bag was filled. *Amigoni family collection.*

Lay wrote. As Lay prepared to invest in this new equipment, he received an offer from Barrett to sell him its plants in Atlanta and Memphis for $60,000. Within a month, Lay had raised $5,000 from friends, received a $30,000 bank loan and got Barrett to agree to accept the rest of the payment in preferred stock. By October 2, 1939, "H.W. Lay Co." signs were up, signaling the start of what would become a potato chip and snack food empire.

While Lay was perfecting the potato chip, Charles Elmer Doolin was becoming obsessed with corn chips. Doolin was manager of a struggling Highland Park Confectionery in San Antonio, and he wanted a corn-based product for the store. According to the Snack Food Association, Doolin found a street vendor selling fried corn chips he had made from masa, a corn-based dough. Doolin is said to have purchased the man's corn chip recipe, a handheld potato ricer and about a dozen retail accounts; some stories contend that he spent about $100 to seal the deal. With his mother's help, the two refined the recipe to produce a corn chip he named Fritos. The Frito company moved the booming business to Dallas in the mid-1930s.

Soon enough, Detroit's potato chip companies would cross paths with these single-minded businessmen. And the city's chippers would never be the same.

# Guaranteed Quality

*I bought a big bag of potatoes, and it's growing eyes like crazy.*
*Other foods rot. Potatoes want to see.*

—*Bill Callahan*

O nce Americans got a taste for potato chips, the demand for these golden snacks grew exponentially. The 1940s would prove a turning point for the industry both nationally and locally as chips grew from a cottage industry to a legitimate business. Potato chips had inched their way into the American diet, and Detroiters in particular were gobbling them up by the bagful. People were eating, entertaining and enjoying potato chips beyond the occasional picnic. New Era spoke to this trend in its advertising, appealing to busy homemakers by noting how its products "help you take a vacation from cooking. Serve them in place of ordinary potatoes. Eliminate peeling and cooking bother." In 1946, the venerable *Joy of Cooking* author Irma S. Rombauer recommended potato chips as a cocktail party hors-d'oeuvre. That same year, the National Potato Chip Institute crowned Dorthea Fagnano, fifteen, of Yonkers, New York, as its first Potato Chip Queen for her "Potato Chips a la Gorton" casserole made with potato chips, carrots, onions and cheese.

By 1948, potato chip companies were selling an estimated 258 million pounds of chips to U.S. consumers, compared to 45 million pounds sold in 1936, according to the National Potato Chip Institute. The industry seemed at its peak, causing even the venerable Herman Lay to wonder if it could

go any further. Lay said in 1949 that he considered selling his potato chip company, according to a September 1969 *Nation's Business* article. "I just felt it was too good to be true. I couldn't see how people could eat more snacks than they were already eating," Lay said. "Instead of tapering off, sales and earnings accelerated even faster."

Detroit's chip makers also saw their fortunes rise in significant ways. There was more competition with newcomers entering the consumer arena. According to the institute's first *Potato Chipper* magazine, published in 1941, its membership of twenty-four businesses included five Detroit-based companies: Cross & Peters, Famous Foods, Mello Crisp Foods, Nicolay-Dancey Inc. and Wolverine Potato Chip Company. Having the institute's red, black and white seal on your potato chip bag was a message to consumers about wholesomeness, freshness and consistency. That seal, which marked a business as being the "King of Chips" with "Guaranteed Quality," was an important distinction, separating a company from home-based chippers and others.

Better Made enjoyed strong growth throughout the 1940s, pushing its earnings to a point where the conservative Pete Cipriano left his milkman's job to join the company on a full-time basis. The company's forward momentum took Better Made through two more location changes during the decade, eventually landing it on one of Detroit's busiest and most well-known corridors.

But its growth was minor when compared to the energy the New Era brand exhibited. With its early start and aggressive ownership, New Era now was hitting its stride and expanding the Nicolay-Dancey empire beyond Michigan's borders and into Illinois, Pennsylvania and Ohio. Because chips are so fragile, opening factories in other states was the only way to ensure they traveled well and got to their destinations unbroken. New Era still called Detroit its home base, but now it was a prestigious regional chipper with friends in all the right places.

As good as sales were becoming in this decade, potato chip companies faced new challenges in a variety of areas. As factories became more established, owners were experiencing the traditional growing pains of any small business. One significant issue was employee safety, as factory fires were becoming an all-too-common occurrence. Nationally, the country's entry into World War II in 1941 created product shortages and a threat to potato chip production that could have shut down the entire industry just as it was heating up. Health concerns from potato chip consumption also grew louder, forcing chip companies to come up with new ways to market their products in the hopes of maintaining their customers and their figures.

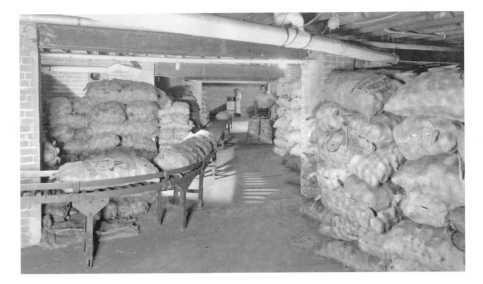

Potato chip companies kept sizable amounts of fresh potatoes on hand for production. Phil Amigoni said that Wolverine's employees stocked its potatoes eight bags high. *Amigoni family collection.*

Factory safety was a primary issue. Reports of fires started showing up in local media reports. The factories were full of flammable products, including paper boxes, cardboard and wax bags. Many companies were still transitioning from kettles and other cooking methods to automatic fryers, so piping-hot oil was always on hand. When a fire struck, the devastation was both financial and personal. In January 1941, a basement fire led to an explosion at Paradise Food Company in Detroit that was so severe that it hurled a radiator and an employee through a huge plate glass window and into the street, according to an Associated Press report. Five people were injured in the blast, including two severely. The building's first floor was completely demolished. According to one newspaper report, "fragments of a six-inch concrete floor, blown through the ceiling into an upper office and storeroom, narrowly missed Mrs. Zygmunt Matuszewski, 30, wife of the company owner." Heavy cooking equipment, steam radiators and furniture were scattered around the building. The blast is said to have rattled neighboring buildings to the point that windows were shattered and a car parked in front was destroyed.

Rationing was another sore spot. Shortages both real and manufactured hit many industries hard at the start of World War II, and chippers were no different. The U.S. war machine needed the very oils that

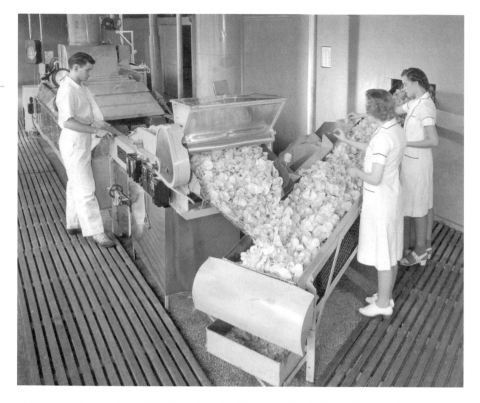

Phil Amigoni supervises Wolverine's fryer in this promotional photo. At the right, two female employees pick out any imperfect chips and put them in separate boxes. *Amigoni family collection.*

potato chip companies used to prepare their snacks. Fats and oils were necessary to manufacture explosive and cellulose—the main ingredient of cellophane—for making gunpowder. Food rationing, along with the threat of making these key potato chip ingredients "non-essential foods" during wartime, put chippers in a dire position. Noss, head of the National Potato Chip Institute, stepped forward as the industry's advocate. In 1942, the NPCI worked furiously to create a document entitled "32 Reasons Why Potato Chips Are an Essential Food." Part of its argument for continued potato chip production was that chips "represented the most efficient and economical way of packaging and shipping potatoes in a ready-to-eat form," according to one account. The NPCI won the day through its successful petitioning of the U.S. Congress on behalf of the industry, and chippers were allowed to manufacture their chips throughout World War II with some restrictions.

# THE SALTY STORY OF DETROIT'S BEST CHIP

As a result of Noss and his quick thinking, the potato chip industry was poised to grow rapidly in the decade to come. A 1943 NPCI survey showed there were 438 chip companies nationwide; about 114 were institute members. It also helped potato chips grow as a product, as other tasty treats that included sugar or chocolate were in limited supply during this period because of rationing and war-related shortages. Considering how difficult it was during World War II to get fresh vegetables and other goods, potato chips were considered a reasonable way to eat your veggies and enjoy the experience.

That may be why concerns about the impact of eating potato chips started to gain a voice. With chips served in schools, hospitals and other institutions, mothers' groups and nutritionists questioned whether moderation was enough to offset the so-called "unwholesome" nature of the product. Mrs. Laura Osborn gained headlines in 1942 for her efforts to remove pies, pretzels and potato chips from Detroit school menus. She called them "indigestible," but her fellow board members were united in their affection for these products. "Mrs. Osborn pleaded for more fruits and vegetables but the six male members of the [school] board, harkening back to the days when they despised spinach and loved pie, voted her down," the United Press reported.

Potato chip company advertisements of the day seem to address these concerns with their gentle yet guiding wording. Better Made tins of the era show concern for customers' well-being: "Better Made Potato Chips are healthful and easy to digest due to the fact that they are made by a special manufacturing process which reduces both the fat and starch content." Mello Crisp tins bragged that its products would help its consumers "Keep that Girlish Figure."

Vita-Boy, which described itself as "The Last Word in Potato Chips," bragged on its tins that "People Like Vita-Boy Potato Chips; They're Good for You!" Vita-Boy also had an array of active, slim figures on its packaging, including a youth playing tennis, a cross-country skier, a twirling ice skater and a female swimmer in the middle of a dive. Its name is a play on the idea that it is a "Vitamin Chip...that Gives You Zip!" The tin also went on to inform the consumer about how much vitamin power its chips packed. "We need from 300 to 500 international units of vitamin B-1 daily. Since it cannot be stored in the body, a shortage is serious. Famous Foods has found an ingenious method of adding Vitamin B-1 to their Vita-Boy Potato Chips to help supply your daily need. 1.5 ounces of Famous Vita-Boy Potato Chips will supply more than 24 percent of your minimum daily requirement of Vitamin B-1."

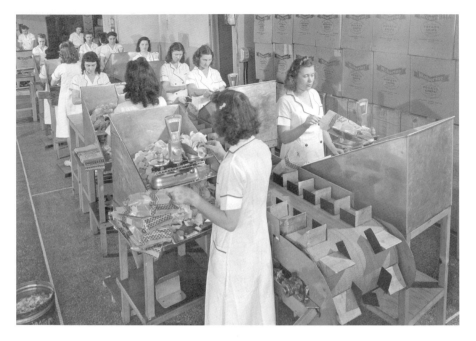

"The Girls" prepared each bag by hand. They first weigh the potato chips for bagging. The bag is weighed a second time to ensure that it is filled to capacity. *Amigoni family collection.*

Perhaps the best-known figure to ever grace a potato chip tin was New Era's slim, shapely female figure whose uplifted arms seemed to imitate that of a ballerina. Her silhouette became a symbol of the chips' supposed health benefits. As one New Era advertisement noted, it was "an easily digested, highly energizing food, delicious for table or picnic." Another New Era newspaper ad took its claims one step further, promising that chips were "less fattening" and adding, "You can eat these Potato Chips unsparingly and keep your weight down." The messaging was consistent. "New Era Potato Chips are used in many of the leading hospitals and health food stores throughout the country and are dietetically considered to be of value to diabetics and persons with weakened digestive systems," the company bragged in its promotional materials. "From its inception, the New Era trademark has stood for fresh, flavor and crisp nutritious potato products, of absolute highest quality, supreme for their nutriment and enjoyment of those who consider health and vigor."

Although numerous women have claimed either to be the New Era beauty or know the woman who inspired it, Russell V. Dancey's daughter Betty Godard said that there is no single woman who served as the model—unless you count the memory of the illustrator's wife.

Companies including Wolverine put a deposit on their tins so customers returned them. The tins were washed and reused as a cost savings. There were times, though, that a tin was so filthy it had to be thrown out because people used it as a trashcan or cigarette depository, employees said. *Amigoni family collection.*

Godard said that New Era's advertising manager was the creative influence behind both the company's name and its legendary silhouette. Tom Schroeder conceived the "New Era" name to replace Best Maid, Godard said, ushering in the company's next generation. Schroeder also drew the female figure that graced the company's packaging, Godard said. She described Nicolay, Dancey and Schroeder as a dream team of sorts for the potato chip company. "Tom was an old newspaper man—he was a sportswriter [for the *Detroit News*] and a cartoonist. He was very good and did a wonderful job," Godard said. "Ernest used to kid him about where he got the idea for the black silhouette, and Tom would say he drew it from memory; it was his first wife."

Dancey and Schroeder maintained a long friendship, Godard said, and they enjoyed sharing a bet or two when the stakes were right. "Schroeder told my father that he was a good wood carver. He said, 'I could carve a duck decoy and win first prize.' My dad said, 'I don't believe you.' So they bet ten dollars, and Tom entered his decoy in a contest. And he did win first prize," Godard said. "Today, Schroeder duck decoys receive a premium among antique collectors."

# BETTER MADE IN MICHIGAN

According to Schroeder's family members, making models became an obsession that would last throughout his lifetime. One evening in 1947, Dancey and New Era's potato buyer, John Heintz, joined Schroeder in his penthouse studio for a catfish dinner. Afterward, the conversation turned to hunting and fishing, and Heintz bet Schroeder that he couldn't complete a rig of fifteen decoys before hunting season opened in October. Heintz lost the bet, and Dancey lost his advertising man. "From that time on, we had a hell of a time getting ads out of him," Dancey supposedly said.

New Era's plant on Grandy was manufacturing potato chips as fast as its workers could manage. Newspaper articles and New Era advertisements from the day outline just how quickly the company was growing. For example, the company reported that the demand for New Era products had reached a point in the early 1940s where its potato purchases were near 9 million pounds annually. It purchased more than seventy-five tons of hydrogenated vegetable shortening every year. Within that decade, New Era built plants in Chicago, Illinois; Wooster, Ohio; and Pittsburgh, Pennsylvania. It distributed its potato chips with a fleet of delivery trucks and highway vans in Michigan, Illinois, Ohio, Indiana, Pennsylvania, West Virginia, Wisconsin and New York. By 1949, the company claimed it was "the largest selling brand in America," with two small bag sizes selling at five and ten cents, as well as three "family-size boxes" at twenty-nine, fifty-nine and eighty-nine cents each.

"The popularity of New Era products has increased rapidly during the past decade. Sales increases each year have been at the rate of over 25 percent and often have been as high as 43 percent. During 1940, over 1.5 million pounds of finished potato chips will be manufactured in New Era's Detroit plant, which is the largest of its type in the country," one advertising piece read. "At the present time, the New Era organization regularly serves more than 30,000 retail outlets each week, whose customers number many millions."

Making sure its now-famous chip tins arrived full and fresh was a priority for the Nicolay-Dancey company as well. The back of one of its early tins shows how much its quality promise meant to the sizable distributor. "To insure whole, unbroken chips, exactly as packed in our factory, the manufacturers of NEW ERA Potato Chips have completely filled this can to prevent the possibility of breakage through shaking of contents. Rapid delivery by specially constructed spring cushioned base supply trucks assure you NEW ERA Potato Chips in the very best possible condition. YOU DON'T HAVE TO SEE THEM TO KNOW THEY ARE GOOD!"

Dancey's religious beliefs along with his convivial relationship with Nicolay were among the reasons why their company had such strong quality

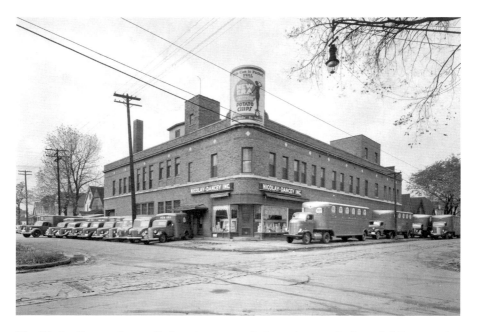

The Nicolay-Dancey factory displays the company's size and stature. Its fleet of delivery trucks flanks the manufacturing facility, which had a small retail store. *Nicolay family collection.*

standards, Godard said. Company promotional materials made the message clear to one and all: Nicolay-Dancey Inc. developed its market while adhering to most rigid business ethics. For example, one of its advertisements noted that "New Era products are sold by direct distribution by the manufacturers and therefore are not sold to dealers who disrupt prices."

Their friendship was the cornerstone of Nicolay-Dancey, Godard added. If the quieter Nicolay had to attend an event, Dancey worked with him to practice until he was considered the best speaker the company had, Godard said. Even their desks faced each other, and they had an open-door policy for all of their employees. "Dad handled the business and sales, and Nicolay was in charge of production.... They worked together very well. They never had a serious argument. They had a few disagreements, but it never got to the shouting stage," Godard explained. "[Nicolay] was great. He was a good partner, and he did wonderful things for the company. He created a variety of machinery for the potato chip industry—he was a forerunner in that field. He would design them and have them built. He created the company's first conveyer system."

Better Made also had a solid reputation throughout its early years, but it took time for it to grow to a point where Moceri and Cipriano worked

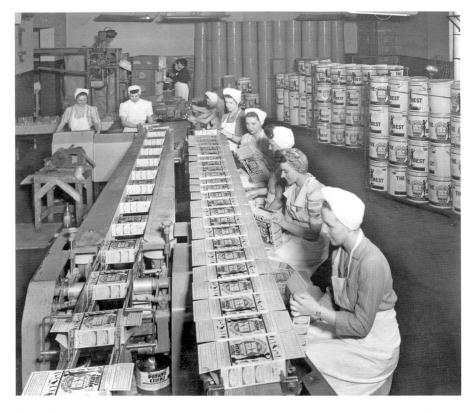

"The Girls" working the New Era production line prepare the boxes for packaging. *Nicolay family collection.*

together on a daily basis. Its postwar upswing in sales would change that. According to company insiders, Cipriano joined Better Made in part to "keep an eye on his investment." This shift proved challenging from time to time. Moceri and Cipriano may have been distantly related, but they were distant in other ways. Around this time, the company started hiring managers who were not related to either of the two owners. Having "outsiders" help manage the company made sense on a variety of levels, family members agree. Not only did they bring new knowledge into Better Made, but they also served as "middlemen" between Moceri and Cipriano.

"They were like two women in the kitchen. They fought constantly," said Sal Cipriano. "There always was a general manager who handled day-to-day operations. They would have executive meetings weekly; they'd sit down together every Wednesday. Majority ruled, so if all three agreed, [Moceri

and Cipriano] would tell their manager to implement it. That was the only way they could get along."

Their disagreements came about for many reasons, but one major cause of dissent was their differing view on how to manage the company. Cipriano was known for having an iron fist when it came to money and how to spend it at Cross & Peters. For example, he despised when Moceri gave out free samples either at work or at his home. Cipriano believed that even the managers and employees should pay for the products. Moceri was known for being the softie; he was a real "lovey-dovey" kind of guy, as former plant manager George Orris recalled. One of former controller Dave Pieper's favorite anecdotes about Moceri is how he enjoyed teasing any children who gathered around the factory. When kids watched the potato chips being made, Moceri stood in front of the windows and pretended to eat the chips right in front of their astonished faces, Pieper recalled. But Moceri always grabbed a few bags to give his youthful audience, making sure that every kid went home with some chips and a smile from the experience.

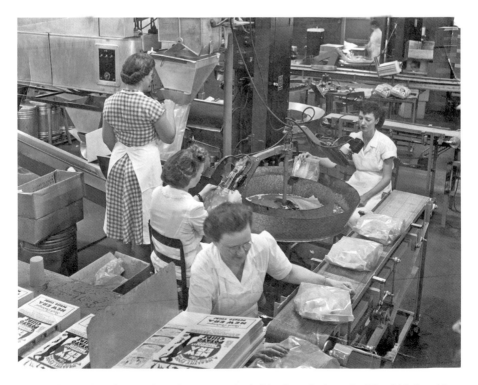

More advanced equipment funneled the finished chips into the bags for "the Girls," making it easier to complete the packaging. *Nicolay family collection.*

"Cross used to give away the store," Pieper said. "He would give away chips left and right. Every holiday, he'd give the employees two bottles of wine—red and white—and a box of chips. You got that every holiday, even Flag Day. That's how Cross was."

It is a memory that many Moceri family members have. "When we were small, he would send the Better Made truck to our house to drop off a case of chips. [He] always thought of his extended family," said Claire Bono.

Although Moceri and Cipriano may have had their differences, they agreed on running Cross & Peters as a "cash only" company. Insiders say that one of the company's best qualities in these early years was that Better Made paid cash for all of its bills and often paid its invoices on the day or within days of receiving them. Cipriano also made sure the company's employees were paid before he received his wages, Isidore Cipriano said. That resulted in happy vendors and happy employees, ensuring that both stuck with the company through thick and thin. That trust would prove essential to Better Made's survival in economic downturns down the road.

"My dad only had a sixth-grade education, and he didn't understand a lot of the bookkeeping that goes into running the business," Isidore Ciprinao said. "But he also had good business sense. He was savvy. He knew if you don't have the money, don't spend it. Don't buy what you don't need."

That strategy was another reason why Cross & Peters could survive and thrive where other chippers fell away—Better Made always had funds on hand for when an opportunity arose, said Pieper, the company's longtime controller. "When Cross and Pete were around, they set aside 25 percent [of their company profits] every year. They didn't believe in debt. Everything was owned free and clear. Every truck. Every piece of equipment," Pieper said.

In the mid-1940s, Better Made moved its now flourishing factory from McDougall to Woodward Avenue in an effort to be closer to downtown. Its new location put the chipper next to large attractions such as the Roxy, Fox Theatre and the Detroiter Hotel, giving the storefront walk-in traffic throughout the day and into the evenings. "I could recall production on Woodward where the girls were packing chips for the one-ounce or two-ounce bags. They had to weigh them and then staple them—Boom! Boom! Boom! Then they'd put them in the box," recalled Russ Leone, Better Made's longtime sales manager.

Those late-night sales would prove prophetic, in part, as the chip company found that it soon had no choice but to make its products after dark. Because the chip factory was located near so many offices, the steam and smell of cooking potatoes was causing havoc on the secretarial pools,

# The Salty Story of Detroit's Best Chip

## ERNEST L. NICOLAY—Born 1899    RUSSELL V. DANCEY—Born 1904

### Teamwork Built Corner Stand Into Big Business

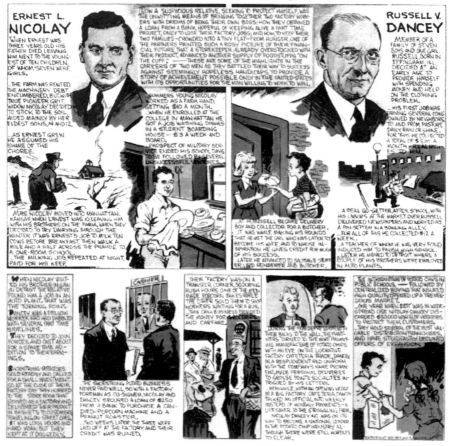

New Era grew to a point that Ernest Nicolay and Russell V. Dancey were the subjects of an editorial cartoon describing their childhoods and early years in business. *Nicolay family collection.*

as Sal Cipriano put it. The heat required the factory to keep its windows open, so there was no escape from the odor of earth, spuds and flying chips. Better Made's neighbors complained so bitterly that the company was forced to cook its chips only during the evening. Add in the fact that the building did not have air conditioning, and you can see why having the windows closed during production hours would prove inefficient and uncomfortable for all involved. Although they were ready to move locations again in short order, Better Made stayed on Woodward until after World War II ended.

"During those years, there was so much walk-in traffic on Woodward," Leone said. "Our smokestacks were pretty high, and it affected offices in the area. They complained about it so much we were told to change our hours or pay a fine....Some of my buddies found out I was working at night, and they'd all come over for potato chips. I'd give them a bag to get rid of them."

Like many Sicilian families who immigrated to the United States, the Leone family had a long history of working with food and food-related companies. Leone followed in his father's footsteps and joined Better Made in 1946, working pretty much every job the chip company had at its Woodward location. Leone started out unloading potatoes, peeling the spuds, working in the warehouse and cooking over the fryer. "My dad happened to know Mr. Moceri and Mr. Cipriano. They all come from the same country, which is Sicily. And when they came to the New World, there were no jobs available. It was just through a matter of friendship and people knowing who went into business who would hire you, like my dad, and give you the opportunity to work," Leone said.

"We'd unload potatoes off the semis every morning before production started. They were one-hundred-pound bags. We'd dump them onto the conveyor and go back to get more," Leone added. "They used to go down a chute into the basement. You'd have to lug the bags around and rotate them so they didn't get rotten. Once the potatoes got rotten, the chips were gone.... And you'd repeat that every day. I worked with Sal Agrusa, unloading the potatoes and clearing them from storage to use as needed. We were a really good team as far as I was concerned."

As the company added capacity, the Woodward location also became more difficult because Better Made was landlocked and could not expand to add the machines and personnel it needed. That led to Moceri and Cipriano looking for a larger space where they could have both a factory and a storefront. A plot of land on Gratiot seemed to fit the bill. It was ideally located near their homes in Grosse Pointe, it was surrounded by Italian families and it had room to grow. Isidore Cipriano recalled how the nearest neighbor to the Gratiot location was a farm. "Over here, it was the Italian Town, and my father and [Moceri]...moved the plant here to draw in the Italian community to work for them," Sal Cipriano said.

To most of the Italian community, the area around Gratiot was known as Cacalupo, explained Isidore Cipriano. "The spot at Harper and Gratiot was a turnaround for a street car. When the Italians started moving here, they called it 'Cacalupo,' or carloop," Isidore said.

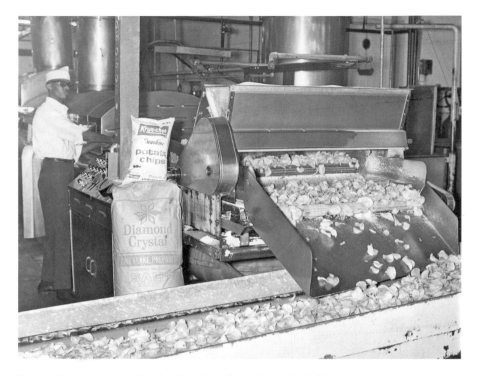

Potato chip companies hired a diversity of employees including women, immigrants and African Americans, drawing from the neighborhoods around them. *Amigoni family collection.*

The drive to work suited Cipriano just fine. He loved his car and often took the family on long Sunday drives, his children recalled. Isidore, who was born in 1938, was soon joined by Salvatore or Sal in 1941. Cathy, whom her brothers say was the apple of her father's eye, was born in 1944. They lived with their grandfather at 1445 Grayton in Grosse Pointe Park until Cathy was thirteen. At that time, Pete Cipriano built the family their own home at 130 Lothrop, and Cathy lived there until she married. While the Grayton house is still standing, the Lothrop house has been torn down, Cathy said.

Having a constant supply of potential workers also suited Cross & Peters. Orris, who managed the Better Made plant for years, recalled how the duo insisted on hiring immigrants from the nearby neighborhood. It was a matter of pride, but it also was about trying to help others who had struggled to start businesses in the area. "All of the Italians would buy from one another. They made sure they gave other Italians their business whenever they could," Orris said.

The small Gratiot factory, with its sizable windows, proved the right fit. Even Better Made's tins bragged about the new location. "Walk by our SUN LIGHTED KITCHEN and see Better Made Potato Chips made from start to finish…. We welcome the opportunity to show you our new, clean, modern and efficient potato chip plant equipped with the most modern machinery money can buy. IT PAYS TO EAT THE BEST."

*Chapter 4*

# The Ringmasters

*Potatoes served at breakfast,*
*At dinner served again;*
*Potatoes served at supper,*
*Forever and Amen!*

*—Pennsylvania prayer*

Potato chips owe a debt to television icons including Jack Benny, Lucile Ball and Ed Sullivan. Thanks to these comedic greats and others, Americans had more reason than ever to curl up together in front of the family TV with a bowl full of snacks. Potato chip consumption reached a new high for the industry during the "Nifty Fifties." It was a decade when households ready to enjoy post–World War II amenities moved to the suburbs, settled into family life, created the "baby boom" and cultivated a comfortable, middle-class lifestyle. TV's first historian, Leo Bogart, wrote that by the mid-1950s "television had established its place as the most important single form of entertainment and of passing the time." In 1950, about 10 percent of American households owned a television set; that figure would explode during the decade, climbing to about 85 percent.

Potato chip companies were poised for growth, and they embraced television for its marketing potential. Chipreneurs sponsored everything from children's programming to variety shows to the Super Bowl. Nicolay-Dancey had been a heavy radio advertiser, but the company soon switched to television. It sponsored multiple shows, including Channel 4's *Musically*

# BETTER MADE IN MICHIGAN

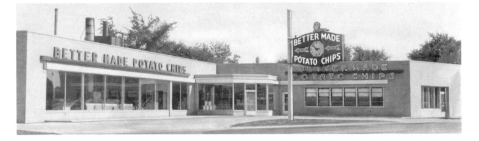

The Better Made factory on Gratiot featured a large retail store and huge windows, which allowed pedestrians to watch the potato chips being made…and occasionally get a free bag from co-founder Cross Moceri. *Better Made archives.*

*Speaking* and *The Auntie Dee Show*, where the reward for performing was a can of New Era chips. By decade's end, annual potato chip sales had hit nearly $500 million, and U.S. consumption was quickly closing in on four pounds per person, according to the National Potato Chip Institute. Even a 1952 potato shortage couldn't stop the industry's progression.

Ernest Nicolay, who became the institute's president in 1954, became spokesman for the industry's rapid development. Thanks to postwar innovations, chippers had equipment that could speed the manufacturing process to new levels. Automation replaced "the Girls" and their staplers. Companies such as Wright Machinery introduced chip factories to packaging machines that allowed them to weigh the chips, funnel them toward different bag sizes and use a heating element to seal them. As a result of this technology, factories were humming; the average chipper could process more than 1,600 pounds of potato chips every hour.

New machines brought about new products. From the potato chip's inception, spuds were thinly sliced and flat. But the 1950s brought about thicker varieties with waves or ridges on them. These rippled versions allowed consumers to scoop up dips without fear of breaking their precious chip in the process. Ruffles, the Lay's version of the ridged chips, was especially successful for the company, forcing other chippers to take notice and begin developing something similar. Chip companies also started to diversify their offerings if they hadn't already done so. Besides chips, companies starting selling related snack food products such as pretzels, popcorn, corn-based products and cheese curls. Some would be manufactured on site, while others came from partnerships with nearby companies to save on distribution costs. The goal was to appeal to a wider audience of U.S. snack food junkies, who gravitated to anything novel on store shelves.

Attending conventions like those organized by the National Potato Chip Institute was a necessity for industry executives. Pete Cipriano and Cross Moceri are the two bespectacled men at the table. *Better Made archives.*

As potato chips became a national treat, companies also began looking at flavorings to differentiate themselves both from in-state manufacturers and those from around the nation. Some of the first flavors chippers introduced were barbecue and sour cream and onion; interestingly, these two flavors, despite their longevity, remain among the best sellers for any chip company in the land. Flavors slowly came on board for giants like Lay's and Herr's in the late 1950s; Cross & Peters would not add seasonings to its chips until the 1970s. However, Cross Moceri's family members, including David Daniels and Grace Bono Van Hecke, said that he created the low-sodium versions of Better Made's Classic chips for his sister-in-law, who had high blood pressure. She missed eating her chips, and this variety was the only one she was allowed to eat in small quantities, Daniels said. He also remembers trying the sour cream and onion flavoring for the first time at Moceri's house.

New companies popped up more slowly now; Detroit during this decade gained chippers including Charles Chips, Yankee Potato Chips and Heintz Potato Company. Chip companies from other states opened small distribution centers around Detroit as well. Mergers were becoming more frequent, as smaller players sought to team up in the hopes of taking a run at established companies. For example, Paradise bought Superior Potato Chips in 1953; the two operated under the Superior name and set up shop on Birwood Street. With these consolidations, some one-man chippers found themselves "sized out" of the industry. A few became employees of their former rivals, working in sales, distribution or management for larger companies. It wasn't uncommon to see people jump from one company to another, hoping to exploit what they had learned from one chipper to another.

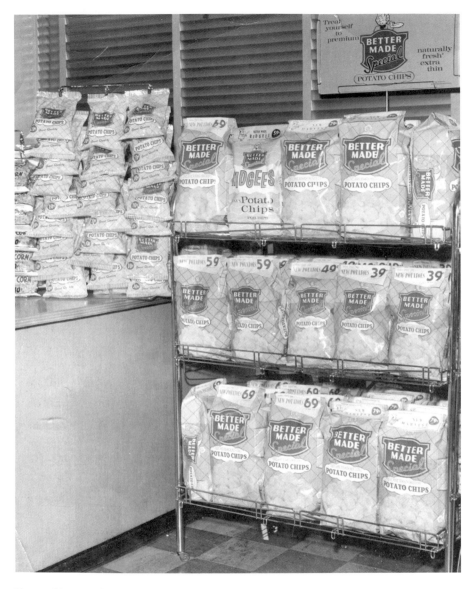

Every chip manufacturer had specific ways it liked its chips to be displayed in its stores or other retail locations, such as bars, grocers and convenience stores. *Better Made archives.*

"To get into the business today, you'd have to be part of a big company or have an awful lot of money," chipper Joe Mossok told a *Detroit Free Press* reporter, recalling the difference between Detroit around this period and when there were "nearly 40 one-horse potato-chip operations in the city."

# THE SALTY STORY OF DETROIT'S BEST CHIP

Ruth Mossok Johnston said that her father was an employee at Everkrisp before moving up over the years to become the company's co-owner by the 1950s. Mossok Johnston added that her father and Carl Krupp purchased Everkrisp, whose motto was "All that the Name Implies," from its owner, Barney Lamond. She remembered going into work many Saturdays with her father, who started at the company as a truck driver. Because her father worked at Everkrisp throughout her childhood, Mossok Johnston said that she was the "Potato Chip Queen," bringing the chips to every school function.

"It was a great way to grow up.... I remember these three-sided wooden carts that they used to use in the factory. I'd take them and pretend they were rocket ships and zoom through the factory in them like they were a scooter," Mossok Johnston laughed. "I was just this little bratty kid that thought this place was mine. It was my playground. I actually apologized to one of the guys who worked there once for how I behaved."

Joe Mossok was a hands-on owner, said Mossok Johnston, and some of those Saturday visits were simply to make sure that day's partial operations were going smoothly. As an only child, Mossok Johnston said that she adored her father and admired his attention to detail. She also remembered going into grocery stores with her father to check out the displays, moving product around if it did not meet his specifications. Under his supervision, Everkrisp was one of the first potato chip companies to offer its products as kosher, which meant no other products could be cooked in the same oil as the chips.

"The only argument that my father and [co-owner Carl] had was over the oil. Some of the chips were turning brown, and Dad was upset about it. Carl was trying to get him to agree to use a cheaper oil, but Dad stood his ground. He couldn't do it," Mossok Johnston recalled. "He didn't want to sell anything that wasn't perfect."

Oddly enough, one imperfection would become a Better Made signature item. Although Better Made's potato chips were known for their snow-white appearance, some customers gravitated to the naturally sweet brown chips that occasionally slipped through Better Made's rigorous in-house screening process. Moceri and Cipriano had these brownish deviants hand-picked out of their finished product and removed from the bagging process. But requests for the chips grew to the point that employees saved those chips in a separate box. At day's end, "the Girls" packaged up what they had pulled off the line, put them into small white bags and stapled them shut. Joseph Moceri remembered that when he and a cousin were working at the McDougall facility, a customer came in and asked for a bag of chips, but he

only had a few pennies on him. They gave him the "seconds," or the brown chips. Soon, he and others became regular customers for these unique chips. The demand for "Rainbow" chips continued to where Better Made started producing them on purpose. "It got to a point where we were selling eight or nine hundred cases of them," Amigoni laughed.

Chippers around the nation had chip-color tester tape for this very purpose. Introduced during the 1950s, the tape reacted to glucose/sugar content in potatoes, Orris said. High sugar content causes brown chips when cooked. Colder temperatures cause a potato's starch to convert to sugar, resulting in a sweet taste and discoloration when cooked. To fool the potato, chippers would slowly increase the heat in the storage areas to make them think it was spring and produce more starch. Through the years, farmers, university agricultural departments and private breeders have developed potatoes with reduced sugar content. But to feed the desire for Rainbow chips, companies started buying special potatoes just to get more browned varieties in their final products.

"With potatoes, you've got about seven to ten days to use them before they start turning to sugar. Once they start to turn, that's where you get the brown chips," Orris said.

By now, shoppers could buy their favorite potato chip brand nearly everywhere. Better Made opened up in the area's newest shopping centers, adding its name to retail rosters in Metro Detroit shopping centers including Northland Mall in Southfield and Eastland Mall in East Detroit, now known as Eastpointe. It made sense to look beyond Detroit's borders; counties including Macomb and Oakland were gaining population as people moved to be closer to a shifting business center. The "Big Three" automakers were decentralizing their operations; during this decade, General Motors Corporation would take its new Tech Center to Warren rather than looking to build within Detroit. At the beginning of the 1950s, Detroit was still sizable, with 1.85 million residents, but the Metro Detroit region was gaining, accounting for about 1.20 million people.

Because of this population shift, delivery routes were essential to getting your product out to the new grocery and convenience store chains. Some potato chip companies already had steady delivery. Others, like the Twin Pines creamery, added branded potato chips to their trucks, bringing salty goodness to your home right along with a quart of milk. Detroit's chipreneurs had to be more aggressive about finding new sales outlets for their products, and that meant hiring young, clever salesmen to expand their territories. For Better Made, its relationship with Russ Leone proved

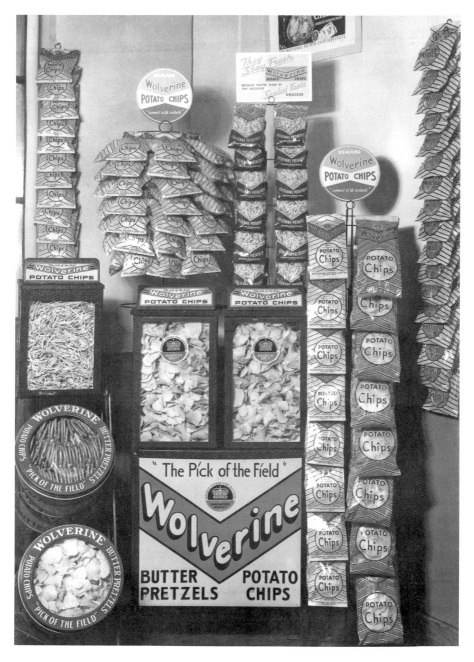

Glass-front containers not only displayed the product but also often had a potato chip company's brand name on them to help promote the product. *Amigoni family archives.*

instrumental in helping the company grow beyond even what its original owners expected. Leone helped Better Made move from just selling chips at its outlet stores and into the area's rapidly growing local chains, convenience stores and supermarkets.

Part of Leone's charm was his modest smile, gentle demeanor and sharp suits, his co-workers said. "He always looked like a million bucks," recalled Orris, who worked with Leone at Better Made for decades.

Selling was in Leone's blood from an early age. Leone was elementary school–aged kid when he became a kind of apprentice to his grandfather. Because his grandfather could not speak English, Leone was enlisted to tag along on his shopping trips to Detroit's legendary outdoor marketplaces for produce at 4:00 a.m. and on his sales routes throughout Detroit. "He wanted me to help him, so every morning we'd head down to Eastern Market. We'd dicker with the farmers and get the best price. Then we'd load up the wagon with all kinds of produce," Leone recalled. "We'd head over to Grand River and Joy Road, where the hockey team used to play. There was this high-rise building, [and] we'd go down there every day of the week. We always came back home empty. My grandfather may not have known how to speak English, but he knew how to talk money."

Like many young men of this era, Leone enlisted in the military. He served as a combat engineer in the U.S. Army during the Korean War. When he was discharged, Leone returned to Better Made and asked for a job—as far as the government rules went, a veteran could come back to his prewar employer and be guaranteed a spot, Leone explained. "I talked to Mr. Cipriano, and with the approval of Mr. Moceri, they asked me if I knew how to sell. I said yes because I had worked with my grandfather. My grandfather had taught me a lot of things," Leone said. "Mr. Moceri asked me, 'Do you want to be a route salesman?' I asked where my route was going to be at. He said, 'There's no route for you. Here's a set of keys to a new truck in the parking lot. That's your truck now. Go out and start knocking on doors.' There was no teacher. Nobody. The only things I knew were the lessons that my grandfather had taught me."

Perhaps his grandfather's best lesson was that you never come home with product still on your truck. Because when Leone went into stores to make a sale, he rarely left without a promise to put some Better Made chips on their shelves. "The first day, I went out on Mack Avenue and picked up about twelve new accounts—beer gardens, bars, grocery stores. I thought, 'This job is like taking candy from a baby. There's nothing to it,'" Leone said. "I would tell them about coming back from Korea and

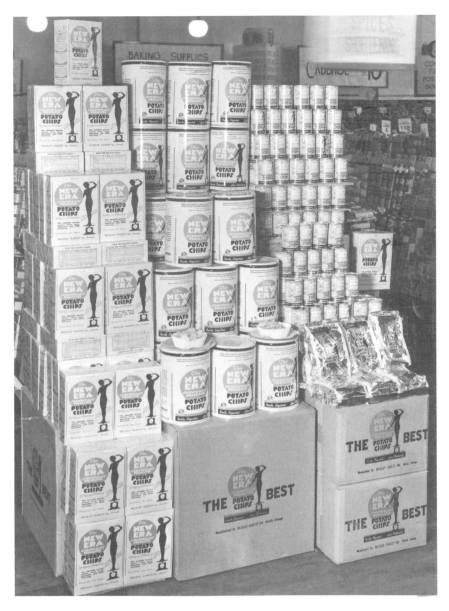

Store displays, such as this one for New Era, were neat and orderly affairs. The smaller cans feature one of New Era's first products, Shoestring Taters. *Nicolay family collection.*

how I was trying to start a new job back here in the States. They'd say, 'For a soldier who protected us, there's a section you can use for Better Made chips right there.' I was in my glory."

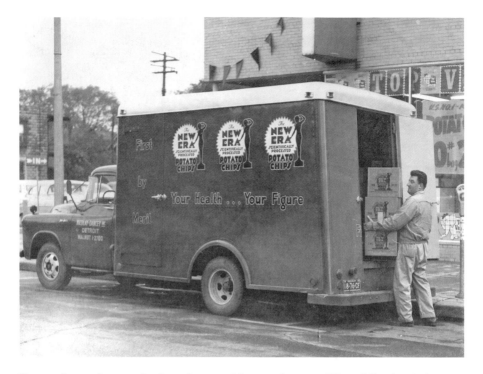

Route salesmen became the face of potato chip manufacturers. When delivering their products, these salesmen interacted with store managers and customers to boost the brand's reputation. *Nicolay family collection.*

Leone quickly realized that major sections of Detroit were untapped. It was "all open territory for me to grab," he said. After two years in sales, Leone had the largest route of Better Made's salesmen. Leone said that he loved his job and the company, so making a sale was everything to him. "When I'd get back to the office, I'd tell the drivers about the new routes. Their eyes would just shine. They would get more commissions from those sales, so they felt just as enthusiastic as I did. I knew I had done my job for the company that day," Leone said.

Leone and Better Made's route salesmen worked diligently to ensure that the Better Made displays were always fully stocked and in pristine condition. It was a drive for perfection that trickled down to anyone who sold Better Made chips. Wes Pikula, vice-president of operations of Buddy's Pizza, said that he remembers how tight he had to keep the Better Made display when he kept bar at the original Buddy's Pizza location at Six Mile and Conant in Detroit. "Those were the days when salesmen like that were larger than life; they could sell you anything. They were like ringmasters with their big

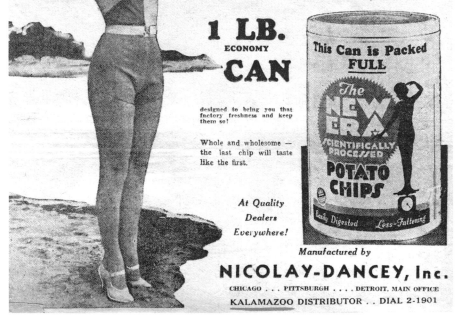

Most potato chip advertisements in the early years emphasized the product's health benefits. New Era was known for its scientifically processed potato chips, which converted the "starch content into dextrine making them less fattening and more digestible—you can eat all you want!" *Nicolay family collection.*

personalities," Pikula said. "I remember how if one clip on the bar display was empty of chips, you'd better restock it fast or you'd get glared at by the manager. We used to keep Better Made under the bar just so we could keep its racks stocked the way it was supposed to be. They were that meticulous. They cared that much about how they were positioned in the marketplace."

Every new account meant that Better Made had to increase its capacity, adding employees and machinery to serve these customers. The chipper's outside management cheered every time Leone came in with another order. However, Pete Cipriano sometimes took umbrage with his company's growth, company employees say. "I had to pick up Pete at the airport one time, and I knew there was a variety store about ten or fifteen miles away. I decided to stop in to that store because I had a few minutes to spare. I went to the buyer and told him I wanted his business if possible. I picked up ten stores from that conversation," Leone recalled. "When I went to pick up Mr. Cipriano, the first thing he says is, 'How is everything, Russ?' I said, 'I picked up another ten stores.' He said, 'Don't pick up any more business.' I couldn't figure him out."

That never stopped Leone. He especially liked snagging hard-to-get customers. "I remember once when Kroger in upper Michigan went on strike. I said to myself that it was time to go after those northern stores. I got in touch with the buyer, who was Greek. I told him that I'd like to bring him to the plant, show him our operation and take him down to Greektown [in Detroit] to get some good food. Well, he turned me down," Leone said. "Then, out of the blue, he called me. He said, 'Russ, we've got a golf outing, and you're going to ride with me.' I knew then I had him. Sure enough, when I showed up, I was in his cart. And I thought, 'I'd better not beat him or I won't get this account.' That got us about ten Kroger stores. Kroger at that time was just as strong as Farmer Jack's for us. It got us a lot of exposure for our name."

Leone more than once ran into Cipriano's stubborn determination to keep Better Made a smaller company. Over the decades, Cross & Peters went 'round and 'round on this issue of how large the company should become, Orris said. While Cross Moceri and his son, Joe, wanted to expand Better Made—even to the point of taking it to other states such as Arizona, where Moceri was ready to open his own branch of the business—Cipriano always sat firm. "[Cipriano] just wanted to keep it small. He was happy with what he had," Orris said.

Isidore Cipriano agreed. "We didn't grow as fast as we should have," Isidore said. "[My father] didn't want to spend any money and expand

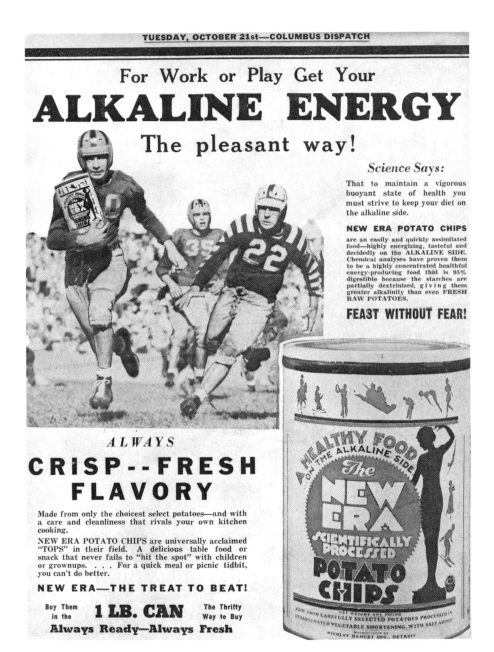

One of New Era's most memorable promises was that the public could "Feast without Fear!" Its chips claimed to be "an easily and quickly assimilated food—highly energizing, tasteful and decidedly on the ALKALINE SIDE." *Nicolay family collection.*

it because he felt he wouldn't reap the benefits, which was a mistake in a way."

New Era, on the other hand, was at the top of its chipping game. In 1951, New Era had four plants in the Midwest, including the Detroit plant. The Grandy factory had the capacity to produce 8.5 tons of finished potato chips daily, company employees said. During this decade, New Era also was heavy into its infrastructure, building facilities like a potato storage warehouse with the capacity of 150,000 bushels, one of the largest of its type. According to one report, the U.S. Department of Agriculture ranked New Era as the largest potato chip manufacturer in the country, with distribution to more than eleven states. Its chips were said to outsell the competition by three to one. In a 1958 report, Dancey told a reporter that New Era had enjoyed steady sales growth of 15 to 20 percent in its previous five years. The company had sales of $8 million in 1953; that number nose to almost $11 million in 1957, Dancey said.

The company's advertisements emphasized its quality, volume and strength. "Folks in Michigan, where New Era Potato Chips were first introduced, now eat more than twice as many potato chips as folks in other states. Try 'em just once and you'll 'taste why'…You'll love their melt-in-your-mouth crunchiness," one newspaper ad bragged.

Potato chip companies were regular advertisers on the mediums of their day. New Era was fond of bus signs, billboards and radio ads to get its name out to the public. *Nicolay family collection.*

Godard said that her father and Nicolay set high goals, and they made an effort to ensure that the company reached them. For example, Dancey created contests for the company's salesmen, distributors and route drivers, giving them motivation beyond compensation. These battles had some comedic results, which created that trademark New Era camaraderie, Godard said. "For every increase in sales that one of the route salesmen had, they would win an article of clothing. At the end of two months, they could win a complete outfit of clothes from the suit to the pocket handkerchief to socks to underwear. At the end of the time, you had to come dressed as what you had won," Godard recalled. "There were a couple of them who were the low sellers, and they had to come dressed in a barrel. Another time, the low man for the month had a goat delivered to him. He was supposed to keep it until the next low man was named. But that ended when one route salesman's kid fell in love with it and didn't want to part with it."

Despite its might, New Era was susceptible to the same woes that befell other chippers. But how it handled these situations and the industry's reaction differentiated the company from its competition, Godard said. A prime example is a 1953 fire at New Era's Wooster, Ohio plant. The blaze, which started inside the factory, was "whipped by high winds and fed by cooking grease," according to one newspaper report. The fire destroyed the entire plant; losses from the accident were said to be more than $100,000. If there was a sunny side to the incident, it was that the fire allowed the company to rebuild. Within months, the new Wooster plant was an impressive sight with the most up-to-date equipment.

New hires at potato chip manufacturers went through rigorous training in how to manufacture their products, including educational classes through the Potato Chip Institute International. *Amigoni family collection.*

"The factory burned to the ground in fifteen minutes. That took out our manufacturing for northeast Ohio," Godard recalled. "My dad had a great many friends in the Potato Chip Institute; those fellows said, 'Send us your bags, and we will make chips for you until you are up and running.' That was pretty nice. They were competitors, but they also were friends."

Nicolay's presidency and association with the Potato Chip Institute also put New Era at the top of its game in terms of national exposure. Its size gained the attention of an important suitor: Frito Inc. Doolin's company wanted to expand its potato chip lineup, and buying out existing businesses seemed like the fastest way to do so. In addition to its merger with New Era in 1958, Frito picked up Crispie of Stockton, California, and Noss's family firm, Num Num of Cleveland. Both Nicolay and Dancey would come along for the ride, joining Frito as executives. According to a 1958 report, Dancey said that Frito acquired Nicolay-Dancey Inc. for a $4 million stock exchange. Shares of this company, which soon merged with Lay and then again with Pepsi, made Nicolay and Dancey wealthier than two country boys could ever have anticipated.

Around the time of the merger, Dancey shared with a local reporter the company's latest television campaign, creating "New Era Scouts," or young people who scoured the countryside looking for the best potatoes for its products. "It builds a good corporate image since, demonstrably, a company must be well-established to maintain a travelling crew of potato scouts," Darcey said. "It has a built-in quality connotation. Pointing out the existence of the scouts shows that we go to extremes to insure the finest potatoes grown anywhere. Besides these, the 'scout' series provides action, humor and, best of all, remembrance."

*Chapter 5*

# The Dream Team

*What I say is that, if a man really likes potatoes,*
*he must be a pretty decent sort of fellow.*

—*A.A. Milne*

Like the rest of the nation, Detroit saw its most dramatic changes in the 1960s and 1970s. The city's population decline took off at an alarming pace as businesses continued their flight to the suburbs, putting empty buildings next to shuttered houses. By 1960, the population in Detroit's suburbs had jumped up 25 percent to about 3.8 million people. Detroit's population, meanwhile, had dropped 10 percent to 1.67 million. Years of racial tensions exploded in July 1967 during a five-day riot over a blind-pig police raid, ultimately resulting in 43 deaths, more than 1,100 injuries and about 7,000 arrests. Not only did people move out of the city in record numbers after these blood-soaked days, but so did jobs. In the ten years after the riot, Detroit lost a reported 110,000 jobs, emptying neighborhoods, shifting the city's cultural diversity and affecting race relations between Detroit's black majority and the largely white suburban population.

It would take time for Better Made to feel the impact of these turbulent years. It continued to focus on building up its customer base within the city, as well as putting an emphasis on the suburbs. Cross & Peters was enjoying the boom years of the snack food industry, growing right along with people's desire for salty snacks. Its exacting internal standards had earned the company a reputation for quality and taste. The company used fresh

potatoes as much as eight months of the year, religiously fried its products in 100 percent cottonseed oil and bought top-notch seasonings from its vendors. That resulted in products that never varied. As a result, Better Made was a profitable company.

Over the next three decades, Better Made kept its focus inward, bringing in a second generation of family employees, with Isidore Cipriano and Joe Moceri becoming managers along with their fathers. Better Made also watched as its competitors began to fade away due to bankruptcies, family buyouts, mergers and other reasons. New Era was largely gone, its name having been replaced by Lay's on chip bags by the mid-1960s. Company advertisements tried to soften the blow: "New Era potato chips come in a new bag with a new name. That's the only difference. The chips are identical. Just say Lay's." Superior bought Everkrisp, and its prospects began to grow. However good things were for Cross & Peters, the company always understood how its fate was tied up with that of the "eight-hundred-pound gorilla" in the room. And that giant primate got even larger year in and year out.

In 1961, Frito and Lay announced their merger, putting together two regional companies to create one very powerful national entity. For the next several years, Frito-Lay worked tirelessly to create a single, uniform potato chip brand. By mid-decade, Lay's golden chips were found in every grocery store across the nation. By this point, Frito-Lay's annual revenues were $127 million. "We set out with one objective in mind—to become national in operations, distribution, advertising and marketing," Lay told *Nation's Business* magazine in 1969. (As an aside, it was a sight neither Doolin nor Nicolay got to see. Doolin died in 1959, and Nicolay passed away in 1960.)

Frito-Lay grew again with the 1965 merger with Pepsi-Cola. The new company was a juggernaut, reporting sales of $510 million and nineteen thousand employees. When the companies merged, Frito-Lay grew to include 46 manufacturing plants and more than 150 distribution centers throughout the United States. The merger made sense for a number of reasons, executives said. There was the obvious combination of salty snacks with a beverage, and PepsiCo did market its products together for a time before the FTC stepped in and prohibited it. But the more important aspect was Pepsi-Cola's international distribution prowess. The beverage company was already in 108 countries at that time, and the merger allowed for Frito-Lay products to go worldwide. By 1970, potato chip sales for all companies were a reported $1 billion; Frito-Lay's sales crossed the $1 billion mark in 1979. Even more startling is how

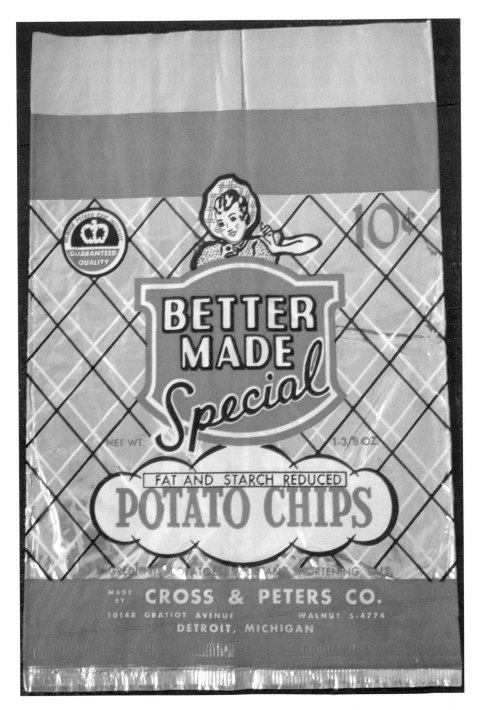

The "Better Made Maid" was a later addition to the company's label; Pete Cipriano is said to have sketched her image at his kitchen table. *Better Made archives.*

consolidations such as this one had changed the potato chip industry. Of the hundreds of potato chip companies in existence in the early 1960s, only ninety-seven would still be in business a decade later.

In 1968, Frito-Lay began construction on a new Michigan factory, settling this time in Allen Park. The downriver facility was set on a fifteen-acre site and was said to be the Dallas-based company's largest and most up-to-date plant in the nation. Although Frito-Lay had long operated within Michigan at the old New Era facility on Grandy, its presence was minor in the grand scheme of things. But having a sizable Frito-Lay plant within Metro Detroit was a new headache for Better Made in its efforts to maintain its regional dominance against the national brand. Even those bowling and other sports teams that once bore the names of some of Detroit's original chips companies now carried the "Frito-Lay" moniker on their backs and in newspaper sports pages.

Another industry upset came about in 1968 when Proctor & Gamble brought a new potato product to market. Pringles were dehydrated, rolled and fried potato flakes and were an "overnight sensation" when P&G introduced them in limited release in Indiana, according to the *New York Times*. The company, which was known for its shortening and other cooking oils, wanted a potato chip product to add to its distribution channels. P&G had its researchers develop a potato-based crisp that would be uniform in size, texture and taste in the hopes of avoiding common customer complaints about air-filled bags or broken chips. The saddle-shaped chips in their long, slim cans fit the bill exactly and went national by 1971. But industry groups, particularly the National Potato Chip Institute, despised the new product and caused an uproar until their complaints to Congress and others forced the removal of the "potato chip" description from the cans. Even Better Made produced advertisements addressing the Pringles controversy. One ad emphasized that Better Made's chips were "unstackable" because of their natural shape and "better tasting" because they did not have dehydrated potatoes. These days, Pringles are still known as "potato crisps," and the brand is a division of Battle Creek–based Kellogg Company.

Chippers, including Better Made, saw the marketplace changing and knew that it was time to step up their game once again. Consumers wanted fresh, innovative products that were tasty and fun to eat. That meant adding interesting products to their standard "original" potato chips to catch this fickle customer in the aisles. John Hanus, who worked for General Spice when he first met Moceri and Cipriano, said that having flavored chips gave

Better Made personality and kept it competitive with other chippers.

Hanus, who worked for a variety of meat and sausage manufacturers in Detroit, had just joined General Spice when he and his bosses drove down Gratiot in 1973 and saw the Better Made plant. They pulled up to the circle drive and peeked into the windows, much like generations of children had done for years before them. Much to his surprise, Hanus said that Moceri and Cipriano were standing there, looking back out at them. They waved to Hanus and his bosses, asking them to come inside. Negotiations went swiftly. Shortly afterward, Cross & Peters started to sell a barbecue chip "just to try it out," Hanus said. It was a huge hit. Sour cream and onion followed, along with hot barbecue, sweet barbecue and salt and vinegar.

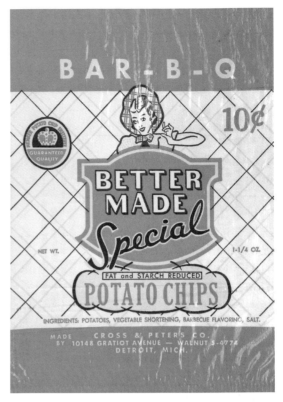

The first flavor Better Made introduced was barbecue. It remains the most popular seasoning the company offers. *Better Made archives.*

The plant as Hanus remembers it was still relatively small then, with a single cooker and a conveyor line. The factory did not have air conditioning, making it unbearably hot. They would open the plant window and turn on massive fans, Hanus said, but it still felt like an oven inside. He remembered delivering twenty-five-pound bags of spice to Better Made; that size was perfect for employees who had to carry the bags up a ladder and onto a mezzanine. There, they emptied the bags into the seasoners.

Over the years, Hanus said that Better Made tried a variety of flavors to see what the market wanted and what it did not. Those that fell flat included curry, bacon, ketchup, National Coney Island and salt and pepper. The spice mix was right and the flavoring was good, Hanus said. The challenge was getting enough

shelf space in grocery stores to show off new products. Without a good display, customers failed to find the potato chips, and the new flavors were pulled.

Soon enough, the new flavors combined with an aggressive sales and delivery team brought about the need for new equipment and warehouse space, and that resulted in the expansion of the small Gratiot storefront and factory. As Better Made added new products and began distributing other brands, it absorbed as many parcels as it could around its Gratiot Avenue headquarters. One expansion was quickly followed by another, taking over spaces formerly held by a farmer, an ice company and other businesses. Better Made found a kind of history of Detroit while it was digging its new foundations, Sal Cipriano said. Some of the best treasures included antique beverage bottles, including ones from the Feigenson brothers, who developed the city's beloved Faygo pop.

A variety of textures emerged as Detroit chip companies grew more competitive with regional and then national brands. Wavetts were similar to a ruffled chip. *Better Made archives.*

However, any construction came with a strict order: you never shut down the line, Isidore Cipriano said. Every detail was covered to make sure the factory ran smoothly and without costly interruptions. "You keep your business going as much as possible. You stick to those forty hours. No overtime because that costs you money. Every time a chip falls on the floor, it costs you money. If you

have a blackout and lose electricity and you have three or four hundred pounds of chips in the oven, it has to be cleaned out. Those chips are wasted. And it costs you money," Isidore said. "Those chips that fall on the floor as they move from machine to machine? Those aren't covered by insurance. You don't get paid for them. You have to find a way to control that. You cannot have waste.... Everything is recycled. Everything gets used. Take cardboard boxes, for example. If you bring them back from the store where you're unloading the chips to the shelves, you can bring those back to the factory. If you reuse it once, that box now costs you less. Use it three or four times and it doesn't cost you anything."

Better Made's facility and production updates came about in part because of the management team Moceri and Cipriano had put in place slowly but surely. It started with their sons—Joseph and Isidore, respectively. To keep the business balanced, the two partners always kept to the "fifty-fifty" rule in all decisions, and that included how many of their children to include in the company. So if Cross had his only child on the staff, Cipriano had Isidore there as well. This idea of "one son for one son" would continue well into the late 1970s.

Those who knew him said that Joe Moceri had a gentle personality yet proved to be a financially savvy manager, a real "money man" who kept an eye on where Better Made spent every penny. He joined the company around 1960 in its accounting department, learning the ropes there before moving upward to eventually serve as the company's chairman. Isidore (or "Izzy") Cipriano tried nearly every job in the manufacturing facility—he had done everything from driving a semi-truck to doing the bookkeeping to stocking the stores. The second generation wasn't guaranteed a job, Isidore said. Rather, they had to show they wanted to be there. And it didn't hurt if they liked the products they were selling. "I was the official taster," Isidore laughed.

However large its capacity became, Better Made's power remained local, as it sold only in southeast Michigan. At Cipriano's insistence, Better Made's footprint remained firmly in Metro Detroit; going west or outside the state required additional plants. Better Made was not alone in maintaining a single-state or regional presence. Potato chips are expensive and impractical to ship. Every semi-truck, despite being filled to the brim with chips, never comes close to its weight limits because the product is so light. More importantly, potato chips simply do not travel well, Orris explained. Anything moved more than four hundred miles experiences what he described as a "shakedown," causing the chips to break more than is acceptable to the industry or to customers.

Boxes were one of three primary packaging options for potato chip manufacturers. The other methods were bags and tins. *Better Made archives.*

"That's why companies like Frito-Lay have so many factories. You have to stay around four hundred miles from your locations; three hundred miles is more normal," Orris said. "When I was with Krun-Chee and then Sunshine, we used to ship as far as Cleveland, but that was it."

One of Better Made's attributes as a company is its long-term employees, and Cross & Peters benefitted during these decades because of solid friendships among Orris, Leone and Amigoni. This "Dream Team" of sorts minimized family disputes and helped to create a company structure that pushed Better Made into a position where it could be competitive with giants like Frito-Lay. The trio, along with Better Made's general managers and family members, was essential in the care and tending of Cross & Peters for decades.

Amigoni came in after serving as a manager at Wolverine about three blocks away on Shoemaker. Amigoni said that Pete Cipriano would stop by from time to time, telling Amigoni that when he was ready to quit there was a job waiting for him at Better Made. Amigoni was ready to jump after Sunshine Biscuit ended up buying Wolverine and Krun-Chee as part of the company's efforts to consolidate into larger entities much like Frito-Lay had done.

Meanwhile, a young Orris was in line to inherit a job at Detroit favorite Milroy's Fish and Chips after completing his army service. Orris figured that

his experience as a cook both before he enlisted and during his years in military service would serve him well at Milroy's, one of Metro Detroit's most beloved seafood restaurant chains.

"My family owned Milroy's at Kelly; my grandmother's brother ran them. He was retiring, and they wanted me to be manager over the two locations. But it would be three months before he retired, so I had to get a job. My brother-in-law was working at Krun-Chee in the warehouse, and he told me he could get me a temporary position in the warehouse. So I took the job," Orris said. "The three months went by. At the same time, I was dating my girlfriend, who had waited for me for two years when I was in the

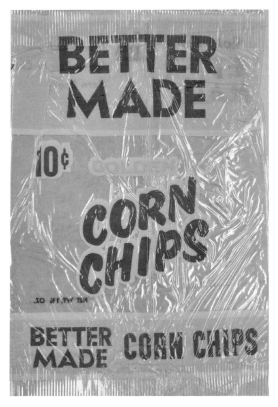

Better Made diversified into other snack food products, such as corn chips, to remain competitive with other area companies. *Better Made archives.*

army. She told me, 'If you take that job, you're going to be working so much that I'm not going to see you all week except on Monday nights. You'll have to get yourself a new girlfriend.' So I stayed at Krun-Chee."

Although he was at a rival chipper, Orris said that they were acutely aware of Better Made and its products. "Years ago, we used to have these weekly meetings at Krun-Chee. We'd send our drivers out to get everyone's potato chips. And we'd take them to a big conference table and open every bag. The other table would hold the Better Made chips," Orris said. "Everybody's quality was checked against Better Made. Better Made's quality was the standard."

When Sunshine took over Krun-Chee, Orris got a new assignment. The company recognized his mechanical know-how, so he started traveling North America, setting up Sunshine Bakery plants in other cities. Most of his work

was modernizing any plant that Sunshine purchased, making sure it had the latest in manufacturing equipment and that its employees were trained to use it properly. Orris started in Windsor, Ontario, and traveled to Milwaukee and then to New Orleans. It was training that would prove invaluable to Better Made, giving Orris an eye for equipment, operations and staffing.

Researching, buying and reselling equipment became a regular job around chip factories. As companies were either purchased or shuttered, other chippers would show up in the hopes of snagging a bargain. For example, Better Made eagerly grabbed a portion of its former rival, New Era. Around 1968, the U.S. Federal Trade Commission started looking into the Frito-Lay

Better Made worked with other companies, including Mr. Chips, to bring a wide array of snacks to its brand name. This pork rinds bag came with a sauce packet if customers wanted additional flavoring. *Better Made archives.*

merger with Pepsi-Cola. The FTC ordered Frito-Lay to sell ten of its plants; in Michigan, the Nicolay-Dancey facility in Detroit was one of the casualties. Amigoni said that he remembers going to the New Era plant and picking over its equipment for Cross & Peters. "Machines went from one company to another on a regular basis," Amigoni said. "If it was something different, you bought it."

Better Made in later years also acquired the New Era brand when it became available. You can see the New Era bags on the shelves at the Better Made facility on Gratiot, a fond reminder of the once great company that existed on Grandy. Better Made runs its products through the New Era bags from time to time, but sales are never as high as the company expects, officials said. They credit the largely lackluster response to the fact that the New Era name has been gone too long from Detroiters' collective memories.

By the early 1970s, Orris was working at a snack foods manufacturing plant in Clinton Township. There, they made everything from pretzels to cheese curls and popcorn. Then they'd turn around and sell them to Better Made to distribute. Amigoni and General Manager Jack McDonald started talking to Cipriano and Moceri about how Better Made could benefit from having both Orris and those snacks on board at Cross & Peters. Amigoni knew Orris from their days together at Sunshine Biscuit, and the two men had stayed friends throughout the years. As a result of their negotiations, Orris joined Cross & Peters in about 1972, bringing his vast knowledge of facilities, equipment and distribution to the company.

Orris's addition set up Better Made to further diversify its product line with the snacks he was making. Upon his arrival at Cross & Peters, Orris helped bring that entire operation to the Gratiot facility. Better Made added on to the plant once more to develop the warehouse space they'd need. His early observations of Better Made's quality made sense when he started working full time with Moceri and Cipriano, Orris said. "If the potato chips came out brown, Cipriano would say, 'Get them out of there.' He'd shut down the line if he had to do it. He wanted them snow white. He liked it when he'd see the snow-white chips. He'd walk by and tell us, 'Beautiful!'" Orris recalled. "They [Moceri and Cipriano] may not have got along about everything, but they did get along about quality."

Better Made operated a minimum of five days a week around this time, sometimes taking production into Saturdays as well. As Amigoni remembered it, Orris and he were the first ones in at about 5:30 a.m. and the last ones out at the end of the day. For these managers, Better Made's schedule went something like this: Check the day's production schedule. Make sure every

Popcorn was a regular snack food company item, and Better Made provided a variety of seasonings to its offerings. *Better Made archives.*

job in the factory was covered. If someone failed to show for work, call for temporary help or move people around. Make sure the cookers were heating up. Plug all of the machines in. Start the lines running to meet that day's production needs. Take inventory. Order raw materials for future needs. Clean up where needed. Put in the orders to the warehouse. Talk to the drivers. Fill the warehouse. Create promotions. Fix broken machines. Create machines to fix problems that showed up on the line. Grab a gentleman's lunch with co-workers. Come back to the factory and do it all over again.

To hear these men speak, you can only imagine that the day-to-day life of running a potato chip factory was idyllic. There were no computers to help Orris and Amigoni manage the company's staffing, handle the ordering or supervise how much product was in the warehouse. They did it with pencil, paper and their understanding of the business. Pieper, who served as the company's controller, said that Orris had a gift for seeing what Better Made needed to order or estimate how many potatoes it should buy every season without spreadsheets or calculators. Even Orris laughs now at how Better Made hired another three people to do his job after he retired. "Phil was good at the paperwork, and I was good at the machines," Orris said. "We made a hell of a team."

Amigoni agreed. "We got along real well. Our minds seemed to work the same way." Orris added that it was the best job of their lives. "We treated it like it was our own. That's the way we looked at it. We treated everything like it was our own. They treated us good, but we also treated them good."

*Chapter 6*

# Balance of Power

*I have made a lot of mistakes falling in love, and regretted most of them, but never the potatoes that went with them.*

—*Nora Ephron*

Sal Cipriano knew early on that his older brother Isidore was the "one son" allowed to work at Cross & Peters, a side effect of the founders' longtime decision to split everything fifty-fifty at the company. "I had to go fend for myself," Sal laughed. As a result, his destiny was his to create, and that suited Sal just fine. After all, Sal had always been the family's adventuresome wanderer. This tendency gave his mother, Evelyn, fits when a teenage Sal would disappear to visit his cousins in the well-known Sicilian section of Windsor for the weekend, failing to tell anyone where he was going. When it came to a career, Sal decided to pursue his lifelong passion for automobiles. It started with a stint at Ford Motor Company, where he worked his way up from a technician to company engineer in eight years. The self-admitted "details guy" said that he once set a record for suggestions at the Dearborn-based auto giant, topping out one year at fifty-two. Sal also had an antique auto parts business that he started in 1970, helping car aficionados like himself find the right piece needed to repair their prizes. He even counted car moguls such as Chrysler executive Lee Iacocca as his clients.

In 1978, Sal Cipriano agreed to come on board at Cross & Peters. His father was getting older, and having another son at the company was finally acceptable to both sides of Cross & Peters. Sal took on a variety of positions

in those early years similar to an entry-level employee, including serving on the maintenance staff. Now it was Isidore and Sal who attended all of the potato chipper conferences, organized under the industry group's new name, the Potato Chip/Snack Food Association. The name change came about to show how diverse the snack foods industry had become; within the next decade, the words "potato chips" would be dropped from the association's name altogether.

By this time, Detroit had gained a national reputation for its potato chip manufacturing muscle, as well as its obsession with the salty snacks. Newspapers in the late 1970s started reporting how the Motor City's per capita consumption of potato chips had reached about seven pounds per year, compared to the national average of four pounds. "Based on our figures and estimates of competitors, we know Detroit people are No. 1. They love their chips," Jack Grifo, president of Superior Potato Chips, told the United Press International. Michigan and the Midwest in general was noted for its particular preference for a "dry, crisp chip that is light in color," compared to chip manufacturers in states such as Pennsylvania that used lard to fry their chips, or in the Southwest, which preferred a heavier chip. These stories also made mention of Detroit's unusually aggressive potato chip market, saying that it was the largest in the United States. "Due to the fierce competition," the UPI noted, "manufacturers are constantly upgrading their equipment and trying to improve their product. A new $300,000, 3,000 pound-an-hour machine is being installed at Better Made to complement a 2,000 pound-an-hour device."

Isidore Cipriano (far left) and Peter Cipriano (second from left) often served as the public faces of Better Made, attending conferences and meeting with other potato chip company owners. *Better Made archives.*

# THE SALTY STORY OF DETROIT'S BEST CHIP

If Sal Cipriano wanted to keep a low profile within his family's company, that hope was short-lived. Within three years, his beloved father would pass away suddenly, and having Sal at the company would prove a greater comfort than the Ciprianos could realize at the time. Peter Cipriano died on April 20, 1981, from an unexpected heart attack. Cipriano had worked regularly at Cross & Peters up until the time of his death with no obvious sign of illness or discomfort. The family was shocked at the loss of their patriarch and leader. He was seventy-seven years old at the time of his death.

To his children, Pete was the man who loved to go fishing, obsessively tend his garden and spend time cooking for his family. He created elaborate Christmas scenes for them, putting train sets around the holiday tree and dazzling them with decorations. He exploded with joy when he saw his children, especially his darling Cathy. To many Cross & Peters employees, Pete Cipriano may have seemed tough as nails at work, keeping a straight face for the sake of the business. At home, however, his children and grandchildren describe him as a caring man who created a close-knit family and a largely blemish-free childhood. His loss propelled the Cipriano boys into greater leadership position at the company. "[His life] is the true definition of the American dream," said Elana Maleitzke, Pete's granddaughter. "My grandfather came over from Sicily. He was a milkman when this started. His work and his tenacity helped Better Made become a success.... He did so much for his family and for the generations to come."

Cross Moceri also was in ill health off and on during the early 1980s, passing away from a long bout with cancer on January 27, 1984. He was eighty-six years old at the time of his death. His family members described him as a man who enjoyed the finer things in life and went out of his way to share them with those he loved. He served a feast at any gathering, bringing in the best treats, including the finest fruit and most succulent seafood from around the country, to meet his "foodie" standards. Moceri traveled in style, taking long vacations when his work allowed. He was generous with his time and with his wealth, bringing presents to everyone when he returned from a vacation or an overseas trip. He and his only son, Joe, had their disagreements, but the two had a loving relationship for most of their lives. Many recall Cross for his positive demeanor and how he always had a smile for those he met. He was the kind of man who cared deeply and loved completely, they say.

"Cross was very generous. He was generous in a way that we didn't realize until recently," said David Daniels, Cross's nephew. Daniels's aunt, Mary, was Cross's second wife; they were together for more than twenty-five years.

# Better Made in Michigan

"We would meet every Sunday at their home, and he would have the best foods imported from Italy. And all of my aunts would cook. We would gather at 1:00 p.m. and not stop eating until nightfall."

With Joe, Sal and Isidore at the helm, the second generation was set to lead Better Made into the next level. They kept the family tradition of working with a neutral third party in top management as well. Having that extra voice in business discussions continued to be an important facet of how the business operated, and it kept everyone seemingly equal. When Jack McDonald wanted to retire, Cross & Peters brought in Bob Marracino to serve as general manager a few years before Moceri's and Cipriano's deaths; now he was moved forward to become the company's new president. With Marracino, they got a potato chip industry veteran who saw Better Made's potential in the marketplace and was eager to expand its reach. Marracino had previously worked at military stores, so his knowledge of sales and product sourcing was second to none, said John Hanus, Better Made's spice vendor. This time around, both families were on the same page when it came to growth—any roadblocks that a reserved Pete Cipriano had previously put in front of the company were now gone.

Having that balance of power, and bringing in experienced management to work at the family-owned business, seemed to keep Better Made heading in the right direction, former employees and family members agree. "I was hired by Bob Marracino. This was the way he explained the [Moceri-Cipriano relationship] to me. He said, 'In order to do your job, you're going to have to take sides from time to time against both families. As long as you're doing your job, I'll back you. Just make sure what you're doing is the best for the company,'" said Dave Pieper, Better Made's longtime controller.

Mike Schena, another longtime chipper who would eventually become Better Made's president, said that Marracino was a professional who understood what Cross & Peters needed to do and when it needed to do it, particularly in his early years with the company. "The family was smart enough to hire someone to run the company. Bob took care of both families, and he took care of the key people," Schena said. "Bob also recognized where his bread was buttered—if he made money and distributed it to everyone, he was golden."

Better Made became a potato chip dynamo in the 1980s with more factory expansions, massive increases in production and regular bonuses to everyone who was now part of the company's success. Incentivizing workers, especially those in management, was an important part of Marracino's strategy for recruiting and maintaining his staff, according to former Better

Isidore Cipriano (left) and Russ Leone (second from right) were among Better Made's second generation of employees. Isidore is Pete Cipriano's son; Russ is the son of Joe Leone, one of Better Made's first hires. *Better Made archives.*

Made employees. Orris remembered how the bonus money Marracino regularly offered as a profit-sharing program helped pay for both ceremonies when his two daughters decided to get married within months of each other. "Those were good years," Leone said. Amigoni agreed. "If there was a way to make money, Bob did it," he said.

As Orris explained it, Marracino had a few unwavering financial rules. The first was that everything had to be paid in cash. The second was that everything had to be paid on time; paying early meant vendors could give Better Made a discount to keep its expenses on track. The third was that Better Made always had an emergency fund on hand. But those funds never sat stagnant in a bank account, making pennies on interest. Rather, Marracino kept it in play, investing it in things like certificates of deposit so the company had regular returns. Joe Moceri was a key part of this strategy, making sure that Better Made had the funds necessary to buy new equipment when the company needed it. He and Marracino were partners in watching any investments that Cross & Peters made during those decades they worked together. "[Joe] always wanted to expand," Orris explained.

Having new products also became a priority. Whereas Pete Cipriano wanted simplicity in terms of what types of potato chips and how many additional flavors were added, Marracino had no such qualms. Now Better Made moved quickly when a new idea popped up internally or from a competitor. Orris said that the management staff would have a meeting, design a new bag, test the product and get it on the shelves in what now

Better Made and other chip companies put their brand names on everything, including these chip baskets. *Daniels family collection.*

seemed like record time. "When Pete was there, we were doing about a million [bags] a year," Orris said. "When he passed and Bob took over, we started growing. And growing. We went up to 50 million a year. There were lots of flavors and lots of equipment. That's how we grew."

Amigoni said that the pace was lightning quick, but the company collectively felt all restraints being lifted and was better for it in many ways. "I ran four cookers every day, five days a week," Amigoni said. "Times when we'd do promotions were even busier. The time before Halloween, we'd run ten hours a day and on Saturdays just to get enough potato chips ready for the push."

# THE SALTY STORY OF DETROIT'S BEST CHIP

The summer months with picnics and outdoor meals are typically the strongest for a potato chip company. But Better Made was able to stretch its peak buying season into October through these Halloween promotions. Leone and the sales team marketed Better Made's one-ounce bags in multipacks, advertising how convenient it was to hand out potato chips rather than candy at Halloween. As a result, Cross & Peters sold so many of these small bags around September and October that the factory lines never seemed to stop running, Amigoni said. Plus, Better Made could hand them out to school groups, Cub Scouts and anyone else who came through the factory for its plant tours, which were highly sought after for children's outings.

Better Made saw its fortunes continue to rise through the 1980s, especially when companies like Frito-Lay stumbled. In 1985, a multi-week Teamsters strike against Frito-Lay limited how much stock the chipper could provide to customers. That gave Better Made the hole it needed to push its products as replacements. In the next few years, however, all chippers would fall victim to troubles beyond their control. Bad potato crops in 1986 and 1987 nationwide caused spuds to double in price in some areas. Companies, including Cross & Peters, had to fight to get enough potatoes to keep up with production. Having that windfall from the Frito-Lay strike gave Better Made the funds it needed to avoid layoffs and maintain its price structure on its products.

One of the negatives of working beside national companies is that when they get into a fight, it eventually becomes Better Made's fight as well. In the 1980s, companies including Borden, Frito-Lay and Anheuser-Busch via its Eagle snacks brand began an all-out pricing war that trickled down to smaller, regional chippers. These companies stopped caring about profits, industry experts said. Rather, they were after shelf space and customers. Smaller companies that couldn't keep up with this pricing competition either went out of business or sold into the larger companies by the dozens.

"Eagle Snacks really started it. They had tons of money behind them because of Anheuser-Busch. It became a price war like Pepsi versus Coke," said Mark Costello, Better Made's vice-president of sales and marketing. "They all started going after each other, and it hasn't stopped since. They're relentless."

These sizable competitors also began offering retailers money in the form of what was called "slotting fees" to get their products onto the shelves or larger amounts of shelf space. Soon enough, retailers began demanding fees to put a chipper's products in key areas of the store, such as the end caps or free-standing racks in the aisles. According to *Crunch!* author Dirk Burhans, slotting fees "ranged from $150 per foot to $500 per foot in the

Better Made put its brand and product images on a variety of novelty items throughout the years, including playing cards. *Cipriano family collection.*

1980s and 1990s to $1,000 a foot annually in 2005. To do business in a single large metropolitan chain could amount to a million dollars a year." Having a prime position even today in a local grocery store means you paid

for it…and then some. "First, [Frito-Lay and others] would come in and pay big bucks to the stores. So, we'd have to come in and pay money to put our chips in there," Orris explained. "It was dog-eat-dog. We had to make a lot of concessions to sell our bags."

These hidden costs are killer, agreed Sal Cipriano. "The more money you've got, the more competitive you can be. It's really that simple. If you're owned by Pepsi and you've got deep pockets, you can buy all of the shelf space."

There were times when Better Made came out on top. As long as the company had the patience to wait out the larger rival, things seemed to turn out well. "One time, Frito-Lay gave some of our distributors some money to switch from our company to their company. So they did. But then they'd notice that Frito-Lay was charging them three to four more cents per bag more than we did. It didn't take them long to realize how much that payout actually cost them. Within six months, they were all back," Orris said.

In 1994, Cross & Peters made a strategic move that would prove to expand its market reach in significant ways. It purchased Bay City–based Made-Rite Chip Company, combining two well-respected names in the snack food industry. The merger served to increase efficiencies at the two companies, giving them a leg up in what had now become an aggressively competitive industry. More importantly, it gave Better Made a way to distribute its potato chips and other products outside Metro Detroit. Made-Rite generally had a lock on the northern portion of Michigan's Lower Peninsula; Better Made had a tight grip on the southern portion. Now, with Made-Rite's help, Better Made could get its products farther into the state than it ever had before. Cross & Peters quickly retrofitted Made-Rite's manufacturing facility into a warehouse and began moving its chips statewide, boosting sales at a time when the company needed them. "In merging, we are combining our resources to assure that we retain our position in this industry," Better Made vice-president Sal Cipriano said at the time. "We just have to be more efficient to survive."

The Made-Rite deal may have saved Cross & Peters, according to former company controller Dave Pieper. Because Better Made sold most of its products in Detroit, the city's downward slide was taking a massive toll on the company. Between 1990 and 2000, Detroit's population slid from 1.02 million to 951,270. And it would become worse. From 2000 to 2010, the city's population fell a whopping 25 percent, falling to 713,777, according to the U.S. Census. Granted, Better Made sold plenty of potato chips outside the city proper, but its residents were among the most loyal to the longtime Detroit chipper. As Detroit's population fell, so did Better Made's overall sales.

Keeping the Better Made brand in front of consumers, like on this tape measure, was one of the reasons the company proved successful over the decades. *Cipriano family collection.*

"We had the tri-county area and just a little bit beyond Flint, but we couldn't break into the rest of the state. Made-Rite had everything around its Bay City location, but it couldn't break into the Detroit area. It was the perfect match, and it gave us the whole state of Michigan," Pieper said. "Another reason Better Made scored in that deal was it gained Mike Esseltine. He is a master at getting new products and keeping drivers hungry to do sales."

Esseltine is a lifelong chipper in his own right. His father was a route driver and a salesperson for Made-Rite, and Esseltine started going into work with him when he was eight years old. "Anytime we had a snow day, I'd beg him to take me with him," Esseltine said. "I grew up in the business."

Esseltine joined Made-Rite in 1984 as a salesperson as well. He first took on the swing routes when another salesperson would be on vacation. Esseltine said that he enjoyed the travel to Michigan's many cities, seeing all of the stores and ways that chips were sold. He was promoted to route supervisor, which meant that he would take over a weaker sales route and troubleshoot to find out what it needed to do to grow. As his knowledge grew, so did his titles, eventually becoming general manager of the Bay City operation for Made-Rite. After the merger, Esseltine became vice-president of sales for the entire company, supervising all route sales for Better Made.

Made-Rite, much like Cross & Peters, was a family-owned business. Founded by the Ruhland clan, it operated out of the home through the late 1930s and early 1940s, Esseltine said. When Clem Ruhland passed away, his three sons—Ron, Bob and Larry Ruhland—took it over and continued to

operate it in the family tradition. "It was the only chip in northern Michigan for many years. Better Made couldn't get past it. It was a bloody nose every time one of us came into the other one's area," Esseltine said.

However, it became clear as the years passed that Made-Rite simply could not produce the volume it needed to survive against larger competitors, Esseltine said. The three sons approached Better Made in hopes of selling, understanding that Made-Rite simply couldn't produce enough revenue to support their families if it continued to operate solo.

Esseltine said that if he has learned anything from working within today's chipping environment it is that you need to have thick skin and be aggressive. He learned that lesson in part from working with Marracino, who put Esseltine through his paces when the two companies merged. Orris, however, kept an eye on the situation, Esseltine said, often calling ahead to warn him when Marracino was going on the warpath. "You better not be on the sales end if you take no as an answer," Esseltine said. "I tell our salespeople, 'Ask ten people. You might get eight of them saying no. But for those two that you get a yes, you've just improved the company.'"

For Elana Maleitzke, Pete's granddaughter and a Better Made sales manager since 2006, Esseltine is the best kind of boss. "He lives and breathes this," Maleitzke said. "He's as tough as nails, but under that there's a heart."

Esseltine is the real deal, agreed Mike Schena, who would serve as Better Made's president for nine years. "He was born to be a salesman. Whatever company I would go to, I would bring him along with me—that's how good a salesman he is," Schena said. "He motivated our distributors and made our products look great."

As Cross & Peters looked ahead at the start of the next century, it was a company comfortable with its regular profits, its processes and its strategy. However, the world around it had changed far more rapidly than the family business realized. Frito-Lay was edging in on Better Made's territory. Along with accounting for more than half of all chip sales nationwide, it had more than $29 million of the $42.1 million in supermarket potato chip sales in southeast Michigan. Meanwhile, Better Made accounted for an estimated $7.3 million in sales at the time.

As long as the economy was doing well, Schena said, Better Made did well right along with it. But if times got tough, the company was largely unprepared. Schena said that the equipment, which was top of the line when it was initially installed in the Gratiot factory, was becoming outdated when compared to industry standards at larger players. Employee morale was good, but its longtime workers were starting to retire. Its sales team,

Better Made created these little "moon men" in honor of the U.S. lunar landings. *Cipriano family collection.*

while effective, was doing things just as it had in the 1950s. And while personal meetings and a handshake were working, it wouldn't be long before supermarket consolidation and supersized company structures would make that method obsolete.

Especially concerning, Schena said, was that most of its managers were getting older, and there were no obvious replacements ready. In an industry where your largest competitor is Frito-Lay, there is no room for complacency. "It was a solid company. It was a very successful company. But it was a business that never had a fire drill; it didn't have an emergency plan in place. It wasn't bringing in new blood. It wasn't keeping up."

## Chapter 7

# The Worst Deal

*It is a mistake to think you can solve any major problems just with potatoes.*
*—Douglas Adams*

As it entered its seventh decade, business seemed to be going well at Cross & Peters. It had survived well past the time when most family-owned companies fall apart. It had outlived every other chipper that existed from its inception, reigning as "Detroit's Best Chip," as it advertised proudly on its yellow-and-red bags. Better Made also had created legions of loyal fans who willingly passed by larger potato chip companies crowding Michigan supermarket aisles to buy its chips, pretzels, popcorn and other products.

Behind the scenes, however, change was coming. After more than seventy years together, the partnership that established Cross & Peters had reached its inevitable end. The rocky relationship between the Moceri and Cipriano families came to a head in 2003, when through a series of meetings the two sides agreed it was time to sell. The Ciprianos bought out what was left of the Moceri clan and, in doing so, nearly destroyed the company that their forefathers worked so hard over the decades to create.

At the time, Sal Cipriano described 2003 to members of the media as a "reorganization year." Looking back at that period, the Ciprianos said that they can see it was one of the company's darkest moments. "We almost folded. We came that close," said Sal Cipriano. "We paid too much for the company, and that took all of our assets."

Peter and Evelyn Cipriano were regulars at family dinners and birthday celebrations. *Cipriano family collection.*

How could something as simple as a buyout go so very wrong that it put a venerable Detroit institution on what some say was the brink of bankruptcy? While there is no single thing that put Better Made in such a tenuous financial position, the 2003 shakeup would serve as a wake-up call to the Cipriano family and its management team, changing the way they did business from that point forward. The simple days were gone; now the business would need to grow up in every sense of the word or face elimination.

Arguably, the partnership's end was rooted in a slow separation between the families with the death of Cross Moceri's only son in 1996. Joe Moceri's passing from heart failure related to a weakened heart from cancer treatments put his half of the company up in the air. Although Joe and his cousins were as close to him as siblings, there was no obvious choice to move up into his position at Cross & Peters. For years, plenty of Moceri relatives had worked on and off at the potato chip company, doing everything from stocking the warehouse to driving trucks to helping with the management team. J. Christopher Moceri, the son of one of Joe Moceri's cousins and Cross Moceri's grand-nephew, even spent a time as the company's vice-president.

It was true that Detroit's economic woes were dragging down revenues. The nation's "Great Recession" had put the entire country into a tailspin. According to those familiar with the negotiations, the Moceri cousins saw that Cross & Peters was going through a related drop in sales. Although not all of them agreed or were even aware of the negotiations, a plan to sell had started to come together.

1..... CIPRIANO ...
2..... PETER ...
3..... TERRACINI ITALY ...
4..... APRIL 12, 1904 ...
5..130 LOTHROP ROAD GROSSE PTE FARMS MICHIGAN USA.

A
Sceau ou cachet de l'autorité
B
Sceau ou cachet de l'autorité
C
Sceau ou cachet de l'autorité
D
Sceau ou cachet de l'autorité
E
Sceau ou cachet de l'autorité

Signature du titulaire*

Peter Cipriano was a devoted grandfather to his seven grandchildren, including Mike Cipriano, Phil Gusmano, Peter Nicholas Gusmano, Peter Charles Cipriano, Peter Jerome Cipriano, John Cipriano, stepgranddaughter Michelle Cipriano and Elana Gusmano. Firstborn sons in Sicilian families are typically named after the father or grandfather. *Cipriano family collection.*

Cross & Peters itself was in a transition of sorts at the time as well. Although he still worked for the company, Bob Marracino no longer served as the man in charge, as his health had started to fail. The families had brought in a financial guru named Daryl Nelson as the company's new leader. While he had an accounting background, company insiders say that Nelson did not have the snack food industry experience or an understanding of the family's longtime politics to guide him. "Accountants can get all the numbers to line up carefully. But they don't take chances," Schena said. As

equipment needed repairs or replacing, it sat untouched under Marracino and Nelson's watch, Schena alleged. And it was Nelson who was in charge when the Moceris and an attorney working on their behalf stepped forward with the idea to sell.

In many ways, Schena said, Cross & Peters was operating on a slim profit margin with little regard for the challenging economic times it was facing. At the Ciprianos' direction, Cross & Peters took the money it had set aside as its savings or emergency fund to pay the Moceris, leaving very little behind for its day-to-day operations. The cost of removing the Moceris basically eliminated its longstanding cash cushion. The business was still making a profit on paper, but its sales weren't strong enough to keep the revenue flowing in a way that made sense, Schena said. It is no exaggeration to say that one misstep could have ended a chipping legacy.

"They came in with a price, and the Ciprianos agreed to it…It was the worst deal ever made in the world," explained Mike Schena, who would become Better Made's president shortly after the sale. "When I got there, I started to realize there was no capital to run this company."

Soon enough, Nelson was out. Sal Cipriano asked around to longtime snack food industry friends for a name as to who would be a good match between the newly emerged Better Made Snack Food Company and his family. The name Mike Schena came up.

Schena may not accept the credit for remaking Better Made in the years that followed, but those around him certainly feel that he deserves a great portion of it. The longtime snack foods executive said that he is not a turnaround expert; rather, he felt a strong pull to help a family-owned dynasty get back on its feet and prepare it for the next generation.

The Boston-born Schena started working in the snack food industry in the 1970s. He was an executive at John Boyd Potato Chips, one of the oldest family-owned chippers in the country, when he left to go work at General Electric. Schena said that he was in an ideal spot at the time— his family was grown, he still enjoyed working and he had accomplished enough to that point that he felt like he could relax. Schena recalled thinking around that time that all of his decades of snack food knowledge

*Opposite, top*: Cross and Mary Moceri enjoy some sunshine. *Daniels family collection.*

*Opposite, bottom*: Joe Moceri (middle) was Cross Moceri's only son. Cross is seated to the right. A family friend is on the left. *Daniels family collection.*

were going to waste as he spent time making jet engines. But it was just a passing thought that he didn't consider beyond that moment.

Around that time, Better Made starting making its own inquiries for a new leader for the company. According to the story Schena heard, the Cipriano family brought in Nelson because they needed someone to run the business for them and went to their accountants for advice. The result was hiring another accountant in the hopes that his money management could help Cross & Peters. However, the relationship never worked the way it should have, and within a few years, it had gone sour. Cipriano next turned to a longtime supplier and asked his advice. After getting a short list of potential executives, Schena got the call.

"I was working at GE and making more money than I had ever seen before. When I told my wife about the job at Better Made, she gave me the eye. I told her not to worry. I said I'd ask for so much money they'd kick me out of the place. I told her, 'They might not be interested.' Well, when they got my resume, they were interested," Schena recalled.

Schena said he sat down with the family and toured the Gratiot plant. He wanted to take the job. The problem came when he decided to present their offer to his wife. "I was working hundreds of hours of overtime [at GE]. I had no life. We only ate one meal together all week," Schena said. "So we decided to take a shot at it."

Among the first things Schena did was to try to figure out how to get the newly minted Better Made Snack Foods out of the legal fracas it had gotten itself into with the Moceri family and its representatives. Both Schena and Pieper say that the sale was a messy legal battle, and the financial wrangling that started in 2003 continued for years beyond that. In the end, Sal Cipriano, his brother Isidore Cipriano and sister Cathy Gusmano emerged as general partners of the newly formed company. Their children also are shareholders.

Schena said that the new company was able to survive that first year after the Moceri buyout because its lenders and longtime vendors were willing to extend it credit. Thanks in part to Moceri, Cipriano and their managers paying everyone in cash all of those decades, Schena said that he was able to get more time to pay off the company's bills and make the necessary changes internally to right the Better Made battleship.

Soon enough, Schena started cleaning house. Firing people wasn't something he wanted to do, he admitted. No one wants to be the bad guy. But he was willing to do it and take the associated lumps because it was the right thing to do for the company, he believed. And as a longtime chipper, Schena wanted to see Better Made come through this crisis. For

Joe Moceri (second from right) spends time with his cousins. *Daniels family collection.*

example, Schena went to every Michigan farm that produced potatoes for the company. Although it may have seemed like a peaceful mission—Schena said that he did want to build stronger ties with Better Made's suppliers—he also was there to send a message, ensuring that his company got the best of the crop. "I said if you don't get me what I want, I'm going to throw you out of here," Schena told *Crain's Detroit* in 2005.

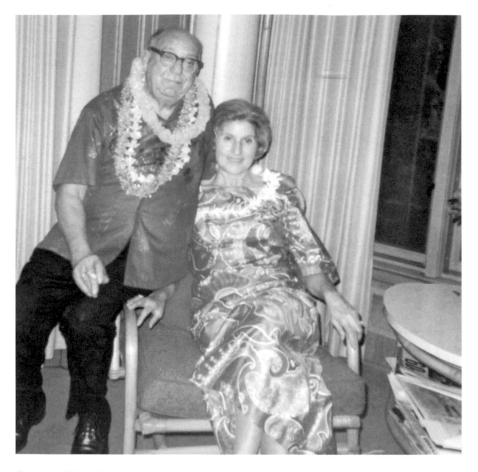

Cross and Mary Moceri always kept the food and drinks flowing during gatherings, nephew David Daniels recalled. *Daniels family collection.*

Every aspect of Better Made's business needed inspection, Schena said. It needed a company-wide computer system. It needed an updated payroll department; its paychecks were still being created on a company typewriter. It was time to build strong departments across the company, and Schena knew that he needed a staff that had youth, industry knowledge and a commitment to turning Better Made into the kind of snack food dynamo that could compete against Frito-Lay and anyone else that would come its way. "Better Made had been very successful, but times were changing. We had to start building. And that meant hiring people with experience—they had to be young, but they had to have experience," Schena said.

Cross Moceri sits at the head of the table. Nephew David Daniels said that Moceri family dinners often started at 1:00 p.m. and went long into the night. *Daniels family collection.*

Luck and timing also seemed to be on Schena's side. In 2004, PepsiCo announced that it was shutting down four Frito-Lay factories by the end of the year. One of those locations was the Frito-Lay plant in Allen Park. Although Frito-Lay took some of its employees to its other locations, many of those Allen Park staffers were left without jobs, Schena said. He called around and got the names of those who were looking to keep working, hiring more than a dozen for Better Made. Simultaneously, Schena also set out to hire a new team of sales supervisors to revamp Better Made's delivery staff and its independent delivery contractors.

"A lot of good people came into the company. They were first-rate people who were devastated when Frito-Lay closed the plant—they felt they had

done everything they could to have made that Allen Park location a success," Schena said. "When they come to Better Made, they were ready to show everyone that Frito-Lay didn't close the plant because of them. It really helped us tremendously."

# Young, Hungry People

*Money is the root of all evil, and yet it is such a useful root that we cannot get on without it any more than we can without potatoes.*

*—Louisa May Alcott*

Throughout its history, there likely were times when Better Made's leadership felt defeated. There surely were moments when they wondered what it would take to keep going despite the huge obstacles that come with running a business. They probably thought about selling the company on multiple occasions when offers came their way. They must have pondered moving from Detroit when the city around them fell into ruin and struggled to reorganize. And they must have felt overwhelmed after the Moceri buyout as they approached the next years with significant financial challenges.

But like the company always had in the past, Better Made kept making potato chips. It kept the line moving. It pushed forward. Whether you can credit it to grit, determination or plain old Sicilian stubbornness, the snack food company on Gratiot never showed its vulnerability. The semi-trucks still delivered potatoes, and the delivery vans left with fresh bags. The chips showed up on the shelves just like they always had. No one knew the difference between the worst days and the best days. And that is exactly how the Cipriano family wanted it. Because while it may be difficult to run their business from time to time, making potato chips is what they do. It is all they want to do. "It's been a labor of love, and I'm proud to have my family carrying on the tradition," Sal Cipriano said.

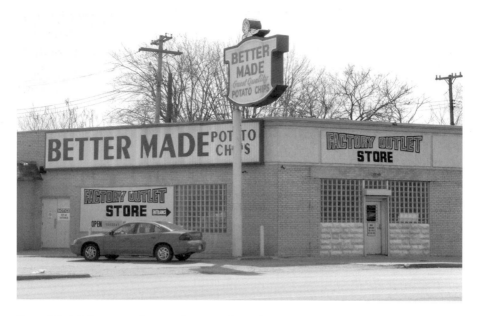

Better Made's factory outlet store has gone through several renovations since the company moved to Gratiot in the 1940s. *Better Made archives.*

Mike Schena knew that, and he set about making a company where the family could continue to work for another generation and beyond. That meant cutting costs, setting up new vendor agreements, buying new equipment and educating everyone around him on what it took to become a twenty-first-century potato chip company. He yelled. He banged his fist on his desk more than a few times. He stomped around the Gratiot manufacturing facility like a bully. To be blunt, Schena "appointed himself dictator. It was exactly what the company needed," said Mark Winkelman, who worked for Schena in Better Made's accounting department. People, including the Cipriano family, didn't like Schena on some days. But when emotions settled, they worked together and got the job done. And Better Made is still churning out chips because of it.

"Mike took them from probably one of their worst times and pulled them through," said Mike Esseltine, the company's Bay City–based general manager and vice-president of sales. Sal Cipriano agreed. "Schena was good for us," he said. "He was tough even on me—even if I hired him. He did what he had to do."

Schena said that he respected the Cipriano family, but they were put in the same boot camp as the rest of the company in those first years. "No one got special treatment. No one got anything because of their name. If anything,

it made their life more difficult," Schena said. "I made that perfectly clear; I was the boss. They would do what I wanted. They could complain, but they ultimately would do it my way because it was the right way to do it. It worked. And they've earned everything they have."

Schena started searching for some fresh faces for Better Made's executive offices. He said that he believes that along with Winkelman, who became company president in 2011, one of his most successful hires was Mark Costello, Better Made's vice-president of sales and marketing. Costello joined Better Made in November 2004 from Chicago-based pork rind maker Evans Food Products Company Inc.

Costello, a marketing major who attended Illinois State University, originally thought that he would go into pharmaceuticals because it was a recession-resistant industry. During college, he was awarded an internship/scholarship at a retail-advertising company and worked there full time after graduation. After leaving the advertising business, Costello was hired by McCleary Inc., now known as Axium Foods Inc. He served as a sales coordinator at Axium, where he met all of the major players in the snack

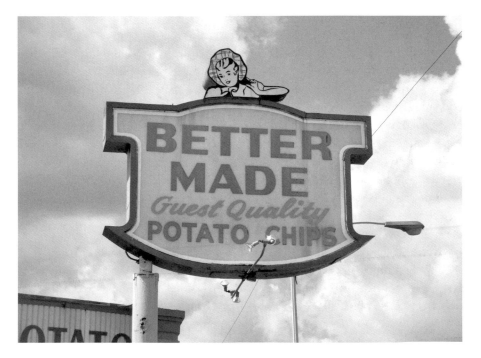

The Better Made sign is an icon along Gratiot Avenue—many professional photographers have captured its likeness and created fine images from it. *Better Made archives.*

food industry in terms of manufacturers and distributors. "I never looked back," he said, realizing that the food industry was just as recession resistant, if not more, than any other. From his position as Axium's sales manager of the co-pack/private label division, he jumped to Evans and served as its national sales guy for more than five years.

Costello said that he was familiar with Better Made because it had been one of his longtime customers during his more than twelve years in the snack food industry. He had worked with Isidore Cipriano, Russ Leone and Bob Marracino up to that point, coming to Detroit every three months and spending the day at Better Made. Costello remembered many four-hour lunches with that trio, hearing all about the company, its products and the city around it. When he ran into Schena at a Better Made golf outing, the two agreed to meet for a business review. By the time Costello left that meeting, he had a job offer to start working in Detroit. Costello started studying Better Made's sales data, trying to figure out a company strategy for its products. As a result, he developed new ideas about how Better Made could capture more of its local marketplace by keying into national trends.

"It's been a really good ride. It's been a lot of work—a lot of hard work. And it's been a lot of change," Costello said. "In my mind, we retooled Better Made for its next twenty-five-year run. We put a lot of these systems and people into place. We modernized it. And we're still doing that. There's always room for improvement. We know that and we recognize that and we focus on that every day."

With some momentum behind him, Schena moved on to a review of the company's popcorn-manufacturing processes. That area was losing money, and it should have been one of Better Made's best areas, he believed. Schena met with people including George Orris and asked them to review the company's facilities and especially the popcorn area. Orris ended up coming back to work for a short time, helping to upgrade those machines in the process. Schena also met with Better Made's longtime suppliers for spices and cheese, upgrading those products as well. Costs went down. Sales went up. Production doubled.

Vendors, distributors and others that worked with Better Made also started to notice the change in the venerable company. Mike Martin, business representative for International Brotherhood of Teamsters Local 337, which represents most of Better Made's employees, told *Crain's Detroit* in 2011 that Better Made's investment in new production and safety equipment shows that the company was aiming for growth, not just survival. Better Made also had just signed a three-year contract with the Teamsters local. "I

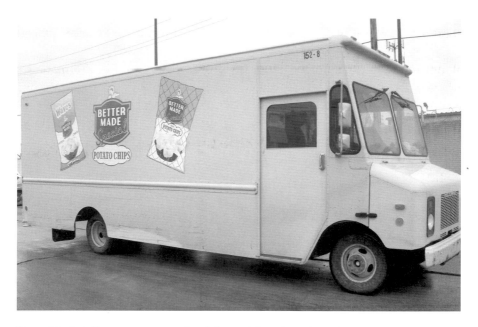

Better Made delivery vans are regular sights on Metro Detroit roadways as distributors stock grocery store shelves. *Better Made archives.*

think under the new management team the company is decidedly becoming more competitive and securing their place," Martin told the local business publication. "I think they appear to have a vision and I think it's going to help ensure the longevity of the company and their financial stability."

In 2004, the family business grew in another way. Cathy Gusmano, the youngest sibling in Pete and Evelyn Cipriano's family, took a full-time job at the company. Gusmano, like her brothers, had visited the factory when she was a child and remembered those trips fondly. But her participation in Cross & Peters stopped there. In her Sicilian family, the girls were caregivers and did not work in the factory. So Gusmano did exactly as her mother did: she took care of the sick both personally and professionally. After her beloved mother passed away in 1993, Gusmano took a job as a volunteer for St. John Hospital. Within a short time, she had found a part-time job within the records department for the healthcare system. Although she was happy at St. John, the changing face of healthcare and insurance had changed the job she once enjoyed. Plus, the lure of working with her family was enough to draw her to Better Made when both Sal and Schena asked her to join. Now, all three of Gusmano's children work for Better Made, and they are often visitors in her office near the Factory

The "Better Made Maid" character is portrayed by female actresses for special events. *Better Made archives.*

Outlet store, which Gusmano supervises along with the company's online sales and social media.

"We have every kind of product: can cozies, shirts, hats. It's all about getting the name out there. We want to saturate the area. And we want to remind people we're here. We're still here," Gusmano said.

# THE SALTY STORY OF DETROIT'S BEST CHIP

If you could be a company man from an early age, you could say that Mark Winkelman has always been a Better Made man. When the company president was growing up, he remembers carrying only Better Made potato chips in his lunch bag and arguing the brand's merits with his classmates at the lunch table. "I never knew I would ever work at Better Made. I never even knew where Better Made was headquartered at," Winkelman said. "I just remember having that conversation in the lunchroom and saying they are the best. They're way better than the other ones out there."

To this day, Winkelman serves as the company's primary spokesman and its biggest cheerleader, conducting countless interviews on the topic of what makes the business work, why it survived over the decades and why people seem to love its chips more than any others. Much like the Cipriano family, Winkelman seems to protect the Better Made image as fiercely as if he owned the company. Winkelman also protects the Better Made legacy out of a sense of pride, borne out of working diligently with the company during its struggles during the 1990s and into today where it stands ready for the future. "We're a team now," Winkelman said of his management staff, the board of directors and Better Made's 150-plus employees. "We've pulled together. We are on the same page. We know what we have to do, and we're striving to get to the next level and the level after that."

Winkelman started working for Better Made in 1994 as a result of answering a blind job advertisement. The Walsh College graduate had worked for a variety of companies since 1989, focusing on accounting for a real estate property development firm, a certified public accounting firm and a home healthcare organization. Ready for a change, Winkelman said that he noticed an ad for an anonymous Detroit-based company and applied. A headhunter called him back and after a few questions told him to show up at the Gratiot facility for an interview. Although he had limited snack food experience, Winkelman said that he was excited to join the company because it always had been his favorite potato chip brand.

For the next five years, Winkelman worked in the Better Made accounting department, doing everything from preparing deposits to doing cost analysis to handling accounts receivable. Those five years he served were symbolic of how much Better Made needed to change, Winkelman said. He recalled how there was no real hierarchy at the company; job titles were limited to a line on a business card. Better Made employees did not have any computers at all when he first started. Eventually, Winkelman talked the office manager into buying one computer, but everyone had to share it throughout the day. Those challenges aside, Winkelman said that he left the company in pursuit

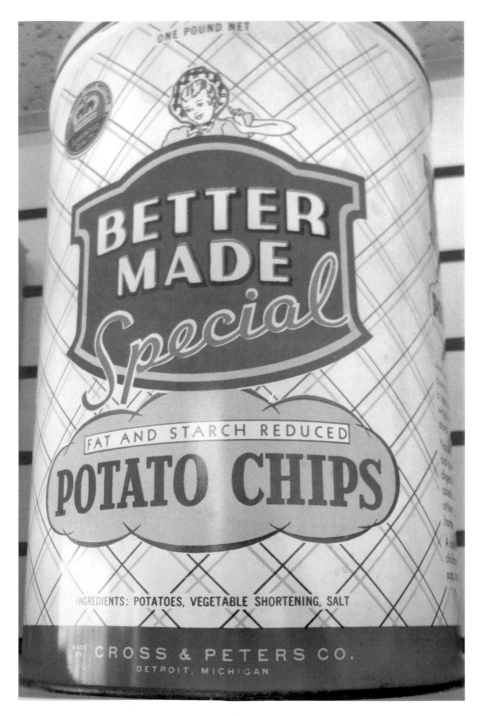

Better Made keeps a stock of both its tins and those of Detroit's other chippers at its Gratiot offices; these are on display in the retail store and Sal Cipriano's office. *Better Made archives.*

of greater career growth. He jumped to other positions, including a two-year stint at Uncle Ray's snack foods, where he helped that business modernize its accounting department as well.

A phone call from Schena pulled Winkelman back again in 2005, joining Better Made as its controller. Soon, Winkelman was vice-president of finance and learning the ropes of management from his bombastic new boss. The work was challenging enough, and this time around Winkelman that noticed the business was changing for the better. So when the Better Made management approached him in late 2010 to take over as president, Winkelman was surprised yet grateful for the opportunity. He was appointed to head of Better Made Snack Foods Company in January 2011.

"The more I thought about it, I decided I could do it. That was youthful hubris," Winkelman laughed. "It was a lot harder than it looked.... We went through some growing pains. I had to gain the family's trust. That was the key thing. And I think I've done that. Plus we have a great team here. They're all tremendously hardworking, street-smart people."

Schena decided that the time had come for him to step down partly because his health was starting to be a concern, and it was time for him to return to his beloved Boston. He felt that the second generation of the Cipriano family—Isidore, Sal and Cathy—were ready to lead as members of the Better Made Board of Directors. Their children were starting to work at the company as well, and Schena felt that the future was in good hands.

"I did what I could do. But they didn't need a hammer any more. They needed finesse," Schena said. "I'm a yeller and a screamer and a pounder on the desk. I used all the methods I had to do to get what I wanted. It was very effective early on, but that doesn't always produce the results you want. I did mellow somewhat, but it was time to move on."

Schena said he felt confident that he was leaving Better Made in the best possible hands with Winkelman. "After all of our blood, sweat and tears, I didn't want to see it go under," Schena said. "With Mark, it's proven to be a good match.... He was familiar with the family, and he knew how to get along with them. If there was an issue, he knew how to handle it correctly."

Schena's legacy in part is the fact that Better Made's current team works well together, Costello said. "He brought in young, aggressive, hungry people who knew the industry. You're only as good as your people. You take that out of equation, you won't have good implementation or good execution. You won't have good service level. The quality isn't going to be there."

Schena is like many of Better Made's veterans—you can take the guy out of the factory, but you'll never take the factory out of the guy. "Two

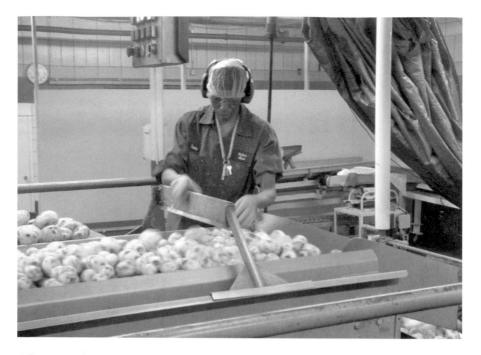

A Better Made employee inspects each potato. This employee also slices any large potatoes in half to make sure they make chips that fit through the company's equipment and into the bags. *Better Made archives.*

people started with an idea to make a better potato chip, and it's grown through the decades. They've had a few bumps here and there, but they grew. And they became a regional powerhouse. It's good for the employees. It's really good for everyone," he noted. "They make a consistently good product, regardless of who was doing what. Detroiters understand what they're eating. They enjoy them. It's the strongest label. I've been involved in three other companies besides this one and worked at nearly a dozen other plants. And it's the strongest label I ever saw."

## Chapter 9
# Fierce Competition

*Potatoes are one of the last things to disappear in times of war, which is probably why they should not be forgotten in times of peace.*

*—M.F.K. Fisher*

**M**odern-day chipping looks nothing like the kettles and kitchens of old. The companies that make, bag and sell potato chips have become, for lack of a better description, no small potatoes. What began as a home-based industry in the late 1920s with a few dozen businesses in Detroit, Ohio, Pennsylvania and elsewhere has blossomed into a snack food monolith. If Pete Cipriano and Cross Moceri were still alive, they likely would marvel at the company Better Made has become and where it is going in the years to come.

Potato chips are the largest segment of the snack food industry, with annual sales of nearly $8 billion, according to industry watchdog Mintel Group. Mintel estimates that eight out of ten U.S. households have potato chips inside their cupboards at all times. More likely is that they have those salty, golden chips sitting in a bowl beside them at least a few nights a week without fail. The largest of all potato chip companies for decades has been PepsiCo, which has about $6.8 billion in sales and more than 58 percent of market share. Its Lay's division continues to be a leading brand within the chip segment of the industry. "You have Frito Lay and then you have everyone else," Dan Malovany, editor of *Snack Food & Wholesale Bakery* magazine, told the Associated Press.

# BETTER MADE IN MICHIGAN

Within this massive marketplace, regional potato chip manufacturers are fighting harder than ever to gain shelf space, recognition and sales, industry experts say. According to the U.S. Department of Agriculture, there were ninety-two potato chip plants nationwide in 2008. That number had dropped to seventy-nine by 2013. Only a handful of the country's original chippers still exist: Utz, Wise, Jay's and Mike-sell's are the last reminders of small-batch manufacturers within the United States. But many are no longer family owned. For example, Wise Foods is a division of Arca Continental, S.A.B. de C.V., the second-largest Coca-Cola bottler in Latin America and one of the largest in the world. Arca is based in Monterrey, Mexico. And Jay's Food Company is now part of Snyder's-Lance Inc., which manufactures snack foods throughout the United States and internationally. The Charlotte, North Carolina company is traded on the NASDAQ. Detroit-based Uncle Ray's, which is still owned by founder Ray Jenkins, became a subsidiary in 2006 of H.T. Hackney Company, a wholesale grocery distribution firm headquartered in Knoxville, Tennessee.

Better Made ranks twenty-fifth in terms of its sales among the nation's top potato chip brands, according to data provided to the Snack Food Association. The fact that it is on that list at all is pretty amazing when you consider that Michigan is Better Made's primary sales territory. It is one of the last locally owned potato chip manufacturers that operates solely in a single state inside one of the most economically challenged cities in America, and yet it still finds itself ranked among the country's biggest and most powerful businesses. That is a testament to the company and to that Sicilian will.

While the Better Made folks don't like to mention the name of that number one potato chip company, its shadow always looms. "You can't relax because the competition is fierce. It's like having a Lowe's or Home Depot next to your corner hardware store. It's like a big ape on your back. You cannot let go for one minute," said Cathy Gusmano. "You wouldn't believe the stress that is involved in a business like this. I said to my brother, 'We make a potato chip for God's sake. It's not an atom bomb.'"

The way consumers approach snacking and even the way that people eat their everyday meals has changed the way the snack food industry works, Winkelman said. "What is described as a snack food has even changed—in the old days, the snack food aisle had potato chips, tortilla chips, pretzels and popcorn. Now you are competing with portable yogurt, cheese sticks, tofu bites, a myriad of granola bars. Not only what is described as a snack has changed but how Americans eat has changed. It went from three big meals

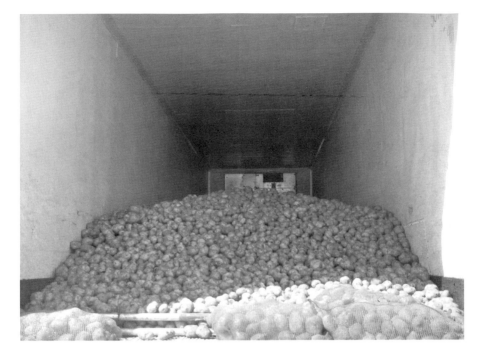

Truckloads of potatoes arrive daily at the Better Made facility. *Better Made archives.*

a day to six small meals. People aren't just eating to eat; they're eating for pleasure. The lines are all becoming blurred."

The data backs him up. The average number of snacks consumed daily jumped from 1.9 per person in 2010 to 2.8 in 2014. Mini meals are becoming increasingly popular, with 28 percent of U.S. consumers saying they eat four or five such meals every day. About 38 percent said they eat three square meals and several snacks each day, while 21 percent said they eat on the run and grab food whenever they can, according to Information Resources Inc., a Chicago-based industry research group.

Consumers also are driving industry change in terms of the healthy aspects of their favorite snack foods. And we're not talking just baked potato chips here—people want to have their crispy fried snacks but with a lighter touch. For example, larger manufacturers like PepsiCo have developed new technology that reduces the amount of oil absorbed by potato chips, noted market-research firm IBISWorld. This means that smaller producers will need to create new technology and processes to produce more healthful chips and snacks right alongside them. And that means further investments in technology, manufacturing facilities,

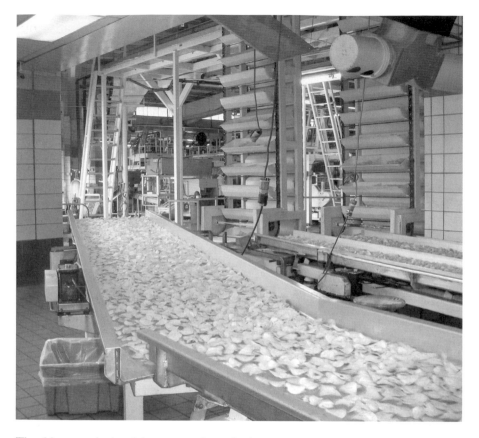

The chips are salted and then sent to the packaging area, where they are put into bags, sealed and then loaded into cardboard boxes for delivery. *Better Made archives.*

equipment, labeling and marketing. The workload generated from every little change can be staggering.

Retailers also have become decision-makers in the process. Big chains have more of a say than ever as to what they will accept in their stores, adding another layer of complication. Sizable chains can force change simply by asking for different packaging or ingredients. Their goal is to put products in their stores that will drive consumer traffic and sales—if that means you have to start over or spend thousands or hundreds of thousands of dollars on research and development…well, that's the way it is today. Add in the costs of slotting fees for the best in-store placement and you can see what manufacturing companies like Better Made are up against even before a shopper ever sets foot in their aisle.

However challenging these trends might seem, regional chippers have experience and loyal customers on their side. There also are surprising side

effects to that loyalty that actually benefit smaller companies. For example, IBISWorld found that the emergence of supercenters and warehouse clubs like Walmart and Costco actually have expanded the distribution of regional products. Yet that also gives rise to new competitors.

Other companies—including Friends, McClure's, Downey's and Great Lakes—have sprung up in recent years, adding variety to Michigan's palate. In 1984, Waterford's Downey Chips set up shop on Dixie Highway, selling its kettle-cooked potatoes to a loyal fan base. Better Made worked with McClure's Pickles for a time, but when that partnership waned, the Hamtramck pickle company started making its own chips with another manufacturer. In 2010, Great Lakes Potato Chip Company began making its version of kettle chips from a Traverse City–based manufacturing facility. President Ed Girrbach said that he started the company for a number of reasons—not only does he love potato chips, but he also saw room in Michigan's marketplace for an additional chipreneur.

Girrbach said that Great Lakes has about thirteen employees, fifteen distributors and more than five hundred mom and pop retail outlets selling its chips, which are made with the skins left on and feature a lighter crunch. Kroger, Meijer and Spartan stores also sell Great Lakes, which can be found in states including Ohio, Illinois, Indiana, Wisconsin and Pennsylvania. The company's intention, Girrbach said, is to be a "significant regional player" within the potato chip industry. He believes that his company's relationship with retailers, customers and Michigan's potato producers help make it a success. "Those relationships allow us to concentrate on the quality of our product. A lot of companies are in the chip business because potatoes are a commodity; they're going to source them from wherever they can get the best price. Sometimes the best price isn't always the best quality," Girrbach said.

Celebrity endorsements and ex-pat nostalgia also help bring Michigan's chip companies to a larger audience. In 2007, Better Made's salt and vinegar chips were named the best of their type in tastings in *Every Day with Rachael Ray*, noted by tasters for their pucker power. Soon after, magician and comic Penn Jillette told *Maxim* magazine that Better Made was his favorite chip. "These are American chips exactly as they should be: not too crunchy, a little bit mushy. You can get a lot in your mouth at once. They also don't have any ridges or added flavor, just salt and cotton-fat goodness. I love these chips." And a *Los Angeles Times* article about a "potato-chip shaped hole in ex-Detroiters' hearts" pushed online sales to their highest level in company history, officials said.

Automated popcorn makers are used to make all of Better Made's popcorn products at the Gratiot factory. Pictured is Pete Cipriano's grandson, Peter Charles Cipriano. *Better Made archives.*

"The Ciprianos have done exactly what a family-owned regional business needs to do. They know their market. They've made their brand name well known to the market. And they've endeared themselves to the market. They've made themselves synonymous with potato chips," said Thomas Dempsey, president and CEO of the Snack Food Association.

Moreover, for every national brand that introduces a new product or a health-conscious change like "Pinch of Salt" potato chips, Better Made either already has a similar product or has the dexterity to create its own version. For decades, Better Made has had low-sodium versions of its potato chips—as mentioned, Cross Moceri is said to have created them after one of his relatives was diagnosed with diabetes and missed having her chips around. Better Made also has "Better Pop" popcorn, a low-oil and low-sodium version of its long-running popcorn line. Sal Cipriano believes that while companies such as Skinny Pop might have greater market share at the moment, consumers will find Better Made's popcorn and make the switch in time. "It's like when the automobile industry started. The first guy made

out real well until people discovered there were better cars out there. It's the same way," Sal said.

The company has a strong "try, try again" mentality that keeps it going even when it seems like it has no chance to succeed. Its most recent flavor success is its sour cream and cheddar—a flavor that fell away for a time but has come back to become a significant sales success for the company, Winkelman said. When sour cream and onion failed to do well on a thinner original chip, they put the flavor on its wavy version and it exploded. The garlic and dill flavor was underwhelming in a three-ounce bag. But put it in a one-ounce size and on a wavy chip, and the result was a runaway success. "This business, it's not complacent. It's kind of like a heavyweight fight— you keep swinging or you get knocked out. You have to change with the economy and the business climate," Esseltine said. "Better Made has the foresight, the intuition and the leadership to grow the business."

There are many reasons why out-of-state companies cannot get a toehold into this region, this state and this city like Better Made has. One is that Michigan is its own animal, Esseltine explained. It is a heavily seasonal

Better Made popcorn goes through the tumblers on its way to packaging. *Better Made archives.*

business, and that requires a special kind of sales strategy. For example, when business slows down in Detroit, it nearly always picks up in the northern areas as people head out to Traverse City and beyond for vacations. Pricing also plays a part in Better Made's sales domination in Detroit, Esseltine said. It understands when to run a promotion, where to price its products and when it needs a push in the advertising department. As the company moved into the west side of the state to boost its Michigan sales, Better Made made a point of introducing itself to the area as in sponsoring sports teams, becoming the "official" potato chip of Van Andel Arena and the Grand Rapids Griffins.

Better Made also benefits from the "Made in Michigan" mentality that the state and businesses promote. These campaigns are both national and local, giving businesses a sales boost because they receive special consideration for being based in Michigan. For example, grocery store chains such as Kroger and Meijer give Better Made more promotion and shelf space because of its connection to the state, Esseltine said. That is important considering the restrictions a regional chipper has; many times, it is cost prohibitive for the local company to advertise, and it cannot receive the economies of scale that a national company has when it comes to advertising.

"There is a movement within the food category to buy and source locally, and that really plays in favor of regional snack makers," SFA's Dempsey said. "Better Made is Detroit's chip. The consumer knows they're supporting a local company that creates jobs within the community."

Potato chip companies including Better Made also have the support of Michigan's potato farmers, who have devoted time, money and research funding toward making the best spuds possible. Michigan potato production generates $1.67 billion in annual economic activity, according to the Michigan Potato Industry Commission, said director Mike Wenkel. Statewide, potato production has increased 17 percent over the last eight years, up from 1.4 billion pounds in 2004 to approximately 1.6 billion pounds in 2012, according to the most recent data available from the U.S. Department of Agriculture. Michigan potato production is spread across more than forty-five thousand acres.

State growers dedicate the majority of their crop, or about 70 percent, to potato chip production, Wenkel said. This is a relatively new development, coming after a 1980s transition away from French fry potato processing toward long-term storage for the potato chip industry, Wenkel said. Michigan now supports most potato chip manufacturers east of the Mississippi about

ten months of the year, Wenkel said. Being able to buy its potatoes locally and for long into its production year helps Better Made significantly.

The science behind potatoes has positively affected Better Made. In the old days, a potato variety would last three to five years before issues such as disease and cross pollination occurred, Winkelman said. Now, hardier varieties make it easier to produce a Michigan-made chip for as much as ten months of the year. "Around the middle of August, we start pulling a variety called Atlantic from the field. While they're harvesting Atlantic and sending them right to our plant, they're harvesting Snowden and sending them to our storage bins. Around November 1, we start pulling Snowdens. We are able to use those two up until about the middle of June or so," Winkelman said. "Then, from the middle of June through the middle of August, we purchase from farmers who are growing in North Carolina, Missouri and Indiana. And then August 15 comes along, and we start pulling from Michigan."

Newcomers such as MegaChip and Lamoka show even greater promise for Michigan's potato farmers and chippers. "These Atlantic and Snowdens have lasted more than fifteen years. Everyone is amazed at those varieties for holding out that long and scared to death that something will happen to them," Winkelman said. "We've been blessed and cursed [because] they've failed to develop a new variety. Within the last couple years, the Lamoka came online. Everyone is super excited about the Lamoka because they store so long."

Efficiency is the new name of the game, Winkelman added. Better Made is always making something, whether it is popcorn or a potato-based product, so the lines run continuously. The equipment, which was modernized in 2011 and 2012, keeps everything moving smoothly. The company also has doubled its capacity, going from an eight-hour production cycle in the days when Orris and Amigoni ran the ship to a seventeen-hour shift most days, Winkelman said. Better Made has established good retailer relationships, co-branding with like-minded products and deep product lines within its established categories such as chips and popcorn. And it is always looking for new relationships with similar manufacturers to bring their items through its distribution chain and get the Better Made name, trucks and drivers on the road and in the stores.

"By being more efficient, more cost effective, we can maintain the quality that people have come to expect," Winkelman said. "In the last U.S. Census, Michigan was the only state to lose population; Detroit lost something like 300,000 people. Our backyard shrunk by 30 percent, but our sales are still

strong. That tells me we are selling more efficiently and penetrating the market better. If a regional chipper can survive in an area where it lost 30 percent of its customer base, then I think we're probably in a good position. As Michigan rebounds, I think Better Made is going to take off along with it."

# City Pride

*To fulfill a dream, to be allowed to seat over lonely labor, to be given the chance to create, is the meat and potatoes of life.*

*—Bette Davis*

B etter Made doesn't just have fans. No, most of the people who align themselves with this chipper are closer to fanatics. They pay tribute to the Detroit icon through band names. They create elaborate potato chip bag costumes, spending hours with a ruler and marker to emulate the classic diamond pattern on the "Original" bag. They suffer through hours of pain to tattoo the iconic maid from the company's logo to their body. There is no end to the creative ways that people have to share their love and devotion to this company and these products.

For Megan Zitlow, her tattoo of the pretty little maid from the top of the Better Made chip bag serves as a reminder of her Michigan childhood. She now lives in Madison, Wisconsin, with her husband, who created the tattoo for her. "I grew up in Michigan. We always had Better Made chips. I was always excited for Halloween because the people in Shelby Forest always gave the snack-size bags," Zitlow said. "I moved to Wisconsin about ten years ago, but I come back home every year to see my family, and every time I get my Better Made chips and bring some back. I have even had my family bring them to me when they come to visit. I love it. It keeps me close to home."

Marlin Page said that the feeling of hometown pride is what brings her back to Better Made as a snack and a brand name time and again. Page

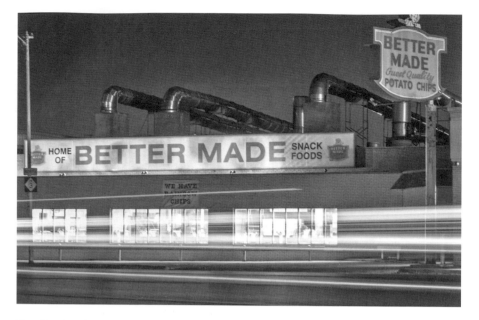

The Gratiot plant, with its bright front sign, inspires many photographers, including Julian Bibb. *Julian Bibb Photography.*

is the founder of Sisters Code and an in-demand speaker about issues related to technology. Recently, she was in Austin, Texas, to present to the audience at the acclaimed South by Southwest Conference. There, she ran into a Detroit-area company, and Page said that she was thrilled when she stepped into their booth to see a Better Made chip display. Page's picture with her favorite hometown chip went viral among friends, who shared her enthusiasm for finding a bit of home when you are on the road.

"I gravitated to the chips. It's a Detroit thing. Better Made is one of those products you know and love as part of the city," Page said. "I love their chips because I grew up down the road. I passed that Gratiot factory throughout my childhood.... I am a Detroiter through and through; I've never lived anywhere else when I've lived in the state of Michigan. So Better Made is like a part of my childhood. For some people, it's the Motor City because of the automotive industry. For me, it's the potato chips. So I was so excited when I saw them at SXSW."

"You see Better Made, and you think of Detroit. You see that factory and you feel that pride. They're there. They didn't run. And you have to be tough to survive in that part of the city," Page added. "Better Made is part of who I am and the pride I have in the city."

# THE SALTY STORY OF DETROIT'S BEST CHIP

Anyone who grew up in Detroit knew that Better Made was the best potato chip, said Wes Pikula, vice-president of operations of Detroit pizza legend Buddy's Pizza. That chip came to symbolize the magic of childhood for Pikula and his friends to such a degree that he admits he has to buy the Better Made brand whenever he sees them in the store just as a reminder of those glory days.

"Every neighborhood had a party store on the corner, and they all sold Better Made potato chips. As a kid, you'd go down there every day. You'd bring a nickel from your paper route or that you made shining shoes so you could buy a bag of barbecue or sour cream and onion chips and a bottle of Faygo, probably orange or grape. You'd pop a lean on the wall and sit there, eating your chips and drinking your pop," Pikula said. "There were other chips on the rack, but no one bought anything other than Better Made."

Better Made also was a signal to those around you that your picnic was the best, Pikula said. He recalled how a bag of Better Made chips on your table meant everyone wanted to be at your party. "When you think of summer, you think of Belle Isle picnics. Everyone had a table, and they'd spread out their food. So when you'd walk through, you would see the bags of chips sitting out there. It was like a badge of honor to have Better Made on your table as opposed to Vita-Boy or some other brand. It determined whether you were high class or not," Pikula said.

Lots of people say that eating Better Made chips is part of their daily routine. LeeAnn Jurczyk said that her family's grandmother has made everyone participate in her Better Made habit. "Grandma eats a bag a week and swears everyone should!" Jurczyk said. When Phil Olter gets his crunch on, the manager of Stosh's Pizza in Centerline said he reaches for Better Made chips. Olter said Stosh's has sold the Better Made brand for more than two decades. "Better taste, better crunch," said Olter, who takes his potato chips seriously. Photographer and public relations expert Jessica Killenberg-Muzik said that Better Made chips have been feeding her family for generations. And she plans on keeping it that way. Her son even was a monthly Better Made baby contest winner, showing off his love of chips from the start.

"As a kid, I remember how all special events, whether it be a birthday party at my childhood home in Harper Woods, family BBQ at Stoney Creek or a trip to my grandparent's cottage near Lexington, would include three iconic Detroit brands: Better Made, Faygo and Sanders," Killenberg-Muzik said. "I'm so glad these brands have stood the test of time, and they have for good reason, as I can now share them with my sons who at 1.5 and 3 years

Baby contests are a regular way for Better Made to connect with its customers. Mom and photographer Jessica Killenberg-Muzik is a longtime Better Made fan. *Jessica Killenberg-Muzik.*

old may be Better Made chips' youngest and biggest fans. Honestly, I think they believe chips should be their own food group. I'm sure the folks at Better Made would agree with their sentiments."

These stories have become part of Better Made lore. The Gratiot offices of Cathy Gusmano and Sal Cipriano are littered with letters, drawings and other tributes to the company that their father helped to found so long ago. There's the woman who sent in a picture of her nephew, weeping over

his box of Better Made chips because his sister stole a handful for herself. There's the prom dress made of Better Made bags, a shining example of how everyone in Michigan pretty much wears their affection for this company on their sleeve.

Snack food company owners return this affection in many ways. Better Made donates to a variety of charitable causes ranging from breast cancer awareness to autism research to area school fundraising auctions. One of the more amazing stories is that of the Dancey family, who have donated millions of dollars from the New Era legacy to further students' educational pursuits. It started with co-owner Russell V. Dancey, who created a small scholarship fund at Adrian College, where he served as a trustee. "He always said, 'If I ever make something of myself, I'm going to help kids like me go to school,'" his daughter recalled. In 1975, he also created the Opal Dancey Memorial Foundation in his wife's name to provide grants to students seeking Master of Divinity degrees and who will serve in pulpit ministry. More than 1,500 seminarians have benefited from Mrs. Dancey's legacy.

Betty Dancey Godard has donated $2 million to Adrian College for a scholarship in her father's name. The Russell V. Dancey Scholarship goes to first-generation college students who otherwise could not afford college. *Adrian College collection.*

Betty Dancey Godard furthered that mission in 2010 with the creation of the R.V. Dancey Scholarship at her father's beloved Adrian College. Godard established the $2 million fund to aid first-generation college students and ensure that they fulfill their dreams of higher education. Because of his family's financial hardships, Russell Dancey was unable to complete his

Children of all ages, especially Sam Brocker, are addicted to Better Made's many flavors. *Blayne Brocker.*

college education, something that he regretted throughout his life, Godard said. In 2014, Adrian College awarded Godard with a Doctorate of Humane Letters for her extraordinary generosity, dedication to students and assistance in supporting families on a path to success, said Adrian College president Jeffrey R. Docking.

"Here he was, a successful businessman, and yet there was this hole inside of him. It was like the seed that never got watered," Docking said. "When we met to discuss the scholarship, she told me that she felt the best way she could honor his memory was to water that seed in others. She believes that the answer to a better life is through education.... We are nearly one hundred years away from when New Era started, but like that proverbial pebble in the pond, its ripple effects will continue for another century."

Docking said that he has been heartened by the relationship Godard has developed with Adrian's scholarship students. He tells the story of when Godard asked him for the addresses of the students who received funds in her father's name, noting that she wanted to send each one a Christmas card. Later, Docking said that he was chatting with one of the students and asked what became of that correspondence. The young man—who had been threatened in his Detroit neighborhood for even wanting to attend college—told Docking that he had indeed received the card; inside, he found a small gift from Mrs. Godard. "That was the only present I got that Christmas," he told Docking.

Bud and Betty Nicolay donated money to Adrian College in 2007 to build Nicolay Field, a state-of-the-art baseball facility with amenities including professional baseball–caliber dugouts, bullpens and batting cages. Prior to this donation, the college was using a nearby public park for its games. Now the field is so popular that Adrian has to turn teams away who want to use it for practices, games and more, Docking said.

Nick Nicolay is a third-generation snack food maker because of his father and grandfather. New Era co-founder Ernest Nicolay worked for Frito for about two years before he died in 1960. His son, Earnest "Bud" Nicolay, went on to purchase Kar's Nuts, a family-owned snack food manufacturer. Today, Nick Nicolay has grown that business into a national company with sales in excess of $90 million annually and a state-of-the-art factory in Madison Heights, Michigan. Nick Nicolay was about three when New Era merged with Frito, but he remembers some of the company's promotional materials. One favorite was his miniature version of a New Era truck, a gift he received when he was three years old. "My grandfather gave one to every grandchild. It had my name and age painted on the side. It was so large you could sit and ride on it," Nicolay recalled.

A variety of Michigan restaurants serve Better Made chips with their entrees. Stosh's Pizza in Center Line carries only locally made product like Better Made. *Phil Olter.*

His best memory? Fresh New Era chips, straight from the fryer. "I will always remember the warm potato chips right off the line. A warm potato chip is just to die for," Nicolay said.

Ruth Mossok Johnston also carries the legacy of her father's work into the present. She is a noted writer, blogger, food journalist and cookbook author. To ensure that her father's legacy lived on, she always includes her maiden name on her projects. She also tells stories of her childhood and her father's potato chip company to anyone who is interested in Detroit and its manufacturing history. One co-worker used to call her "Chips" as a result. Having a father who cared deeply about food and what he presented to others had a lifelong effect on her, she said. "He was absolutely the best role model to grow up with—he was kind. He was good to his workers. He cared deeply about quality. I've tried to emulate those kinds of behavior in my life and career," Johnston said.

Caring about chips is essential to the company's success. Better Made's longtime employees not only say that they feel like the people there are friendly, but also that they have become family. An estimated 75 percent of the company's 150 or so employees live within a five-mile radius of the Gratiot factory, company officials say. Despite occasional disagreements—this is like a family, after all—they work together to make a product that they are all proud to represent.

# THE SALTY STORY OF DETROIT'S BEST CHIP

Shirley Leija has worked at Better Made for about thirty years. The Lincoln Park resident started at Better Made in about 1985. Leija said she was a single parent and had to find work. She had worked at a snack food company previously, so Better Made seemed like a great fit. Her sister's friend got her an interview for a job on the factory floor, and Leija went to work as a packing assistant. From there, she worked her way up to the factory store, where she has been for nearly all of three decades at the company.

"We all did the hand packing, like when you had to pull the dark chips off of the line for the Rainbow Chips. It was hard, physical work," Leija said. "I remember working at Halloween was the most difficult. That is when you had to work so fast, and you had to work like a team. If you got behind, that put the whole team behind. It was difficult, but it was fun, too."

Like most Better Made employees, Leija is pressed when asked to come up with her favorite flavor. "I love them all," Leija said. Among her favorite parts of the job is the managers' open-door policy and how she has known every Better Made president by name. "I work with good people. These girls, especially. They've been a part of my life just as I've been a part of theirs. We're like family. There's always something to do—always. It's a good place to work. And if you needed anything, you knew you could go to the president any time you needed."

Megan Zitlow loves her Better Made chips so much she got a tattoo of the "Better Maid" on her leg. *Megan Zitlow.*

# Better Made in Michigan

Vanessa Logan started at Better Made in 1979, straight out of high school. She, too, was a packing assistant at first, moving to the factory store for the past fifteen years. "This is my favorite part of working at Better Made—getting people their chips," Logan said. Her attitude, she said, is much like that of Pete Cipriano, whom she remembers walking through the plant when she first started at the company. Their mutual philosophy? "When I'm on the job, I make it the best it can be."

Hiring Detroiters is another of the company's long-lasting traditions. "We hire local. In an area where a lot of minimum wage jobs exist, we pay a decent salary and provide benefits," Phil Gusmano, vice-president of purchasing, told one reporter.

For Better Made's third generation, the company is both their inheritance and their livelihood. They fuss and argue, but they also love working for the business that their grandfather helped to start. They understand that none of it is promised or guaranteed. "It's one of the blessings that he left us," said Elana Maleitzke, a Better Made sales manager, Cathy Gusmano's daughter and Pete Cipriano's granddaughter. "I never forget where it came from. I love it very much."

# To Be the Best

Detroit is known for certain things: Motown music, the Joe Louis fist, car companies…and that red-and-yellow "Original" bag of Better Made chips. It's there every time you crave something salty. It's there when you feel hungry for a little taste of home. It's there when you want to share something that defines Michigan with someone living outside the state, helping with that empty space that only love can fill.

Better Made has earned the title of "survivor." It is the only chipper that has made it from its early beginnings in the 1920s. Just as they did in Detroit, other Michigan-based chippers, including Be-Mo in Kalamazoo and Paramount in Flint, disappeared. Better Made is the only locally owned original left, providing nearly the same quality, product and promise it offered with Cross Moceri and Pete Cipriano all those years ago. Its devotion to its product has never left that factory, and its strict attention to details remains strong with the second and third generations that now work at Better Made. When Sal Cipriano tells you that he and his family never want to sell the company, you truly believe him. "As long as we're successful in continuing to diversify our operations while maintaining the level of quality, Better Made can easily be sustained for another seventy years," Cipriano said.

Why do we love Better Made so much? It's about pride, family and loyalty. It permeates every part of Better Made's persona. It's found in the sign hanging in Mark Winkelman's office that reads, "Proud to be a Spudman." It's heard in every conversation with Sal Cipriano that begins and ends with

# Epilogue

the same sentiment: "We never wanted to be the biggest chip company. We only wanted to be the best."

What no marketing company, industry analyst or outsider truly understands is how being part of Detroit defines Better Made in a way that no other company can ever touch. It started with two immigrants who had a dream of making something better—they wanted to share a bit of themselves in every crispy bite. It defined them. It defines Detroit.

Better Made—as well as all of the chippers that came before and any that might come afterward—are all part of the salty story of the city's potato chip manufacturing. That grit. That unbelievable resilience. That strength of character to keep going despite what anyone throws at you. That ridiculous refusal to back down even when the eight-hundred-pound gorilla is smacking you around. In fact, for every hit, a Detroiter comes back harder than before. That's a fact and then some.

Better Made is the ultimate icon of that determination. Every time you drive by that factory, you are reminded that Detroit, despite all efforts to the contrary, is still standing. And in many ways, that is just as satisfying as the potato chips that come off Better Made's production line every day.

# Selected Bibliography

Bak, Richard. *Detroit: A Postcard History*. Charleston, SC: Arcadia Publishing, 1998.

———. *Images of America: Detroit 1900–1930*. Charleston, SC: Arcadia Publishing, 1999.

Burhans, Dirk. *Crunch! A History of the Great American Potato Chip*. Madison: University of Wisconsin Press, 2008.

Delicato, Armando. *Images of America: Italians in Detroit*. Charleston, SC: Arcadia Publishing, 2005.

Heim, Michael. *Exploring America's Highways: Michigan Trip Trivia*. Wabasha, MN: T.O.N.E. Publishing, 2004.

Krass, Peter, ed. *The Book of Entrepreneurs' Wisdom: Classic Writing by Legendary Entrepreneurs*. Hoboken, NJ: John Wiley & Sons, 1999.

Lucas, Edmund W., and Lloyd W. Rooney, eds. *Snack Foods Processing*. Boca Raton, FL: CRC Press, 2001.

Martelle, Scott. *Detroit: A Biography*. Chicago: Chicago Review Press, 2012.

# Selected Bibliography

Poremba, David Lee. *Images of America: Detroit 1930–1969*. Charleston, SC: Arcadia Publishing, 1999.

Reader, John. *Potato: A History of the Propitious Esculent*. New Haven, CT: Yale University Press, 2011.

Silverman, Sharon Hernes. *Pennsylvania Snacks: A Guide to Food Factory Tours*. Mechanicsburg, PA: Stackpole Books, 2001.

Smith, Andrew F., ed. *The Oxford Companion to American Food and Drink*. New York: Oxford University Press, 2007.

Snack Food Association. *50 Years: A Foundation for the Future. Snack Food Association*. Alexandria, VA: self-published, 1987.

Zuckerman, Larry. *The Potato: How the Humble Spud Rescued the Western World*. New York: North Point Press, 1999.

# Index

# INDEX

## H

Hanus, John 76, 88
Heintz Potato Company 59

## J

Johnston, Ruth Mossok 61, 134
Jurczyk, LeeAnn 129

## K

Kar's Nuts 133
Killenberg-Muzik, Jessica 129
Krun-Chee 13, 32, 35, 80, 81

## L

Lay, Herman W. 38
Leija, Shirley 135
Leone, Joe 26
Leone, Russ 32, 52, 62, 68, 110
Logan, Vanessa 136

## M

Made-Rite 93, 94, 95
Maleitzke, Elana 87, 95, 136
Marracino, Bob 88, 99, 110
Mello Krisp 13
Moceri, Cross 10, 12, 18, 24, 25, 26, 59, 68, 87, 98, 117, 122
Moceri, Joe 74, 79, 89, 98
Mossok, Joe 60, 61

## N

New Era 13, 25, 28, 35, 37, 41, 42, 46, 47, 48, 49, 58, 70, 71, 72, 74, 76, 82, 83, 131, 133, 134
Nicolay-Dancey 42, 48, 49, 57, 72, 83
Nicolay, Ernest 13, 20, 58, 133
Nicolay, Nick 133
Noss, Harvey 38

## O

Olter, Phil 129
Orris, George 32, 51, 110

## P

Page, Marlin 127
Paradise 35, 43, 59
Pieper, Dave 35, 51, 88, 93
Pikula, Wes 66, 129
Potato Chip Institute 38, 41, 44, 58, 72, 76

## S

Schena, Mike 88, 95, 96, 99, 100, 102, 103, 104, 105, 106, 108, 109, 110, 111, 115
Schroeder, Tom 47
Superior 13, 59, 74, 86

## V

Vita-Boy 35, 45, 129

## W

Wenkel, Mike 124
Winkelman, Mark 12, 108, 109, 113, 115, 118, 123, 125
Wolverine 13, 32, 35, 42, 80

## Y

Yankee Potato Chips 59

## Z

Zitlow, Megan 127